SPLIT SECONDS

FOUR DECADES OF NEWS PHOTOGRAPHY FROM THE PACIFIC NORTHWEST AND BEYOND

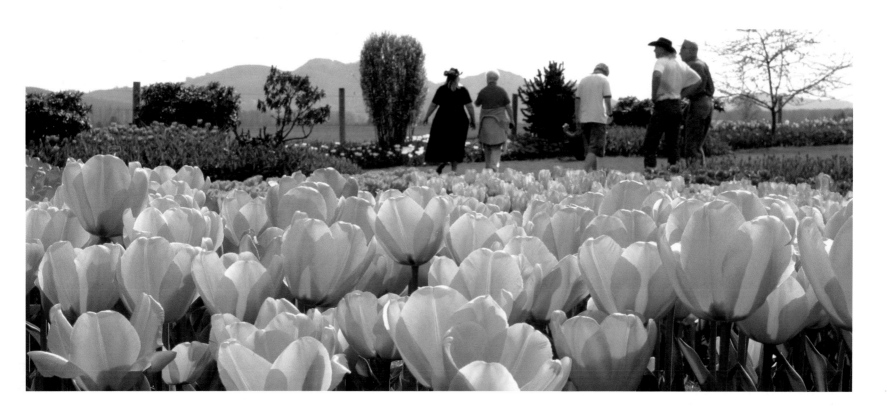

photography by
BARRY SWEET

TEXT BY JOHN T. MARLOW

RALEIGH PRESS

To Raleigh, Corrie, and Jason

Thanks to Ed Stein and Dick Sroda of the *Wisconsin State Journal*,
Rich Clarkson of the *Topeka Capital-Journal,* and Hal Buell and John Marlow
of The Associated Press for their support, assistance, and friendship.

Editors: John Marlow & Kent Sturgis
Proofreader: Patty Sturgis
Cover & text design: Elizabeth Watson, Watson Graphics
Printer: Bang Printing
Distributed by Aftershocks Media/Epicenter Press

Photos by Barry R. Sweet, ©2012 The Associated Press, published with permission

Library of Congress Control Number:
ISBN 978-0-615547-367

10 9 8 7 6 5 4 3 2 1
Printed in the United States of America

To order single copies of SPLIT SECONDS,
mail $19.95 plus $6 for shipping (WA residents add $2.30 state sales tax) to
Epicenter Press, PO Box 82368, Kenmore, WA 98028; call us at 800-950-6663,
or visit www.EpicenterPress.com. Find *Epicenter Press* on Facebook.

Cover photos:

Front cover, from left: An artist works on a huge painting of Mariner superstar Ken Griffey Jr. on the side of a downtown Seattle building in June, 1993; members of the Seattle Liberation Front riot outside the U.S. Courthouse in Seattle in February, 1970, resulting in twenty injuries and seventy-six arrests; a couple shares a good-bye kiss in February, 2004 as 4,000 members of the Washington Army National Guard's 81st Armored Brigade prepare to depart for Iraq in the largest deployment of state guard soldiers since World War II; U.S. Sen. Robert F. Kennedy runs through the surf of the Pacific Ocean near Astoria, Oregon with his dog Freckles in May, 1968 during a stop on his campaign for the Democratic presidential nomination prior to his assassination soon after in Los Angeles; no one had ever heard of Madonna in April, 1985 when she performed in her first concert at the start of her Virgin Tour in Seattle; Mrs. James Kaufman surveys the wreckage of her home after a tornado swept through Topeka, Kansas in June, 1966.

Back cover, from left: Thousands of Boeing employees celebrate the launch of the new Boeing 7E7, later to become known as the Boeing 787 Dreamliner, in an April, 2004 celebration in Everett, Washington; a giant balloon depicting the Statue of Liberty lifts from a hill at Seattle's Gas Works Park in July, 2003 as the city prepared for a giant Fourth of July celebration.

Page 1: Visitors stroll through one of the many flower gardens in the colorful Skagit Valley during the spring blooming season in 2004. The annual Skagit Valley Tulip Festival in April, organized in 1984 by the Mount Vernon Chamber of Commerce, attracts millions of visitors who feast their eyes on hundreds of acres of tulips. Tulips were introduced in the valley from Holland in 1906 and today sale of tulips and bulbs is a multi-million dollar industry; Facing page: Jack Eickerman, 3, is amused by his reflection in a distorted mirror at a family-day event sponsored by the American Association for the Advancement of Science in Seattle in February, 2004.

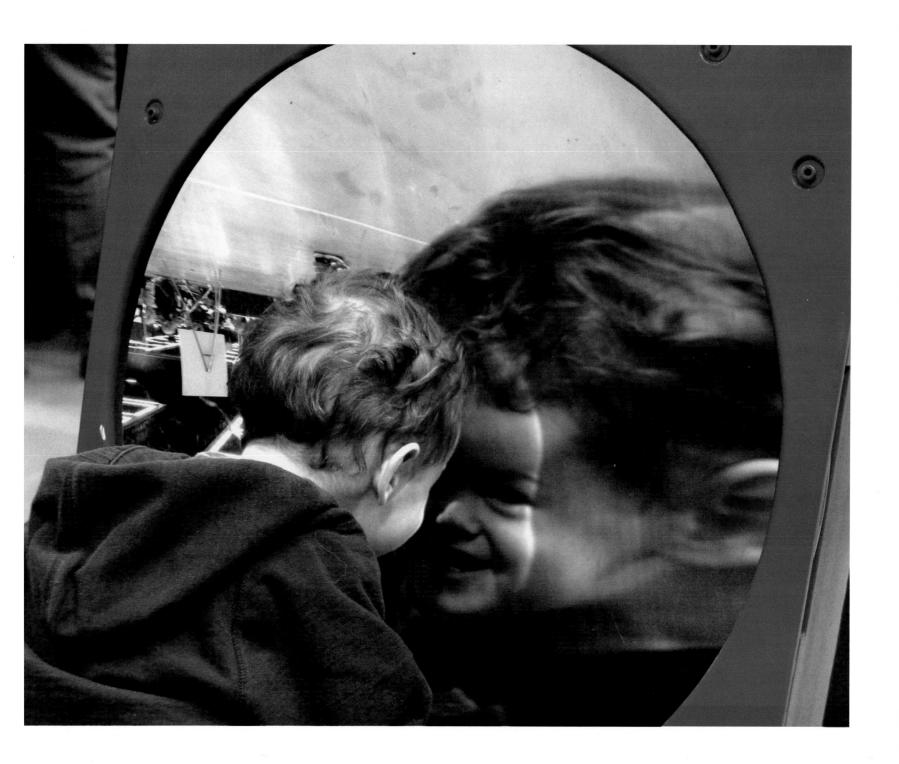

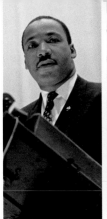 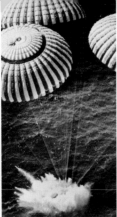 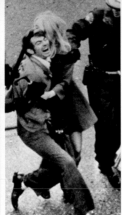 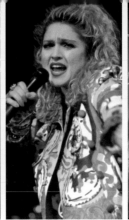 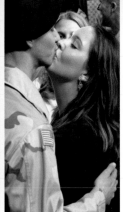

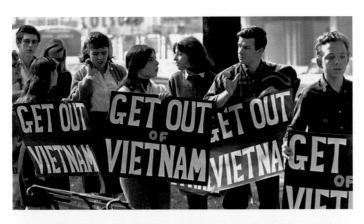

1960s

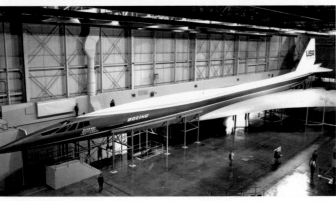

1970s

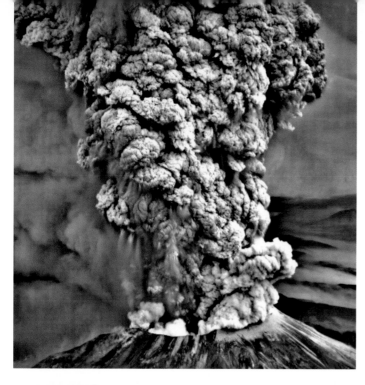

1980s

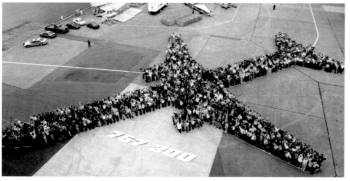

1990s

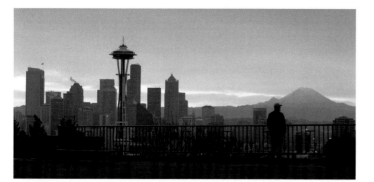

2000s

Preface

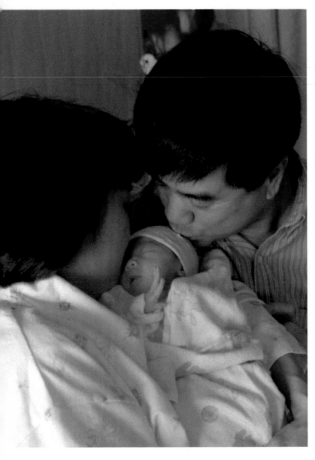

Former Washington Governor GARY LOCKE and his wife, MONA LEE, greet their firstborn, EMILY NICOLE, at the Swedish Medical Center in Seattle on March 10, 1997.

Trust. That's what it took to build relationships with subjects. Photojournalists had more access in the early years. In the 1960s and 1970s, few if any security people ran interference as I photographed politicians and celebrities. We were one on one with these people.

Personal access was still possible during the terms of three Washington governors I most often photographed Dan Evans, Dixy Lee Ray, and Gary Locke. There were no security agents or squads of policemen getting between us and our subjects.

Governor Locke and I had a good working relationship. I had taken pictures of him during election campaigns, at his inauguration, and in his office in the Capitol. He knew who I was and what I was doing. When the first Locke child was born, the governor was besieged by photographers requesting permission to shoot pictures. Wanting to protect his family's privacy, the governor asked me if I would take pictures of him, his wife, Mona, and their new baby girl, Emily, and then distribute them to the other news media.

I worked well with Governor Ray, too. I had taken many photos at the Pacific Science Center when Ray was director there. After she decided to run for governor, I asked for a photo session. Her reply was, "Okay, Barry, I'll hop into my Jeep and drive over to your office."

Governor Evans would invite me to his office or into the Governor's Mansion where he showed me his scrapbooks and personal memorabilia, just the two of us. It was a personal connection that gave me an advantage doing my job.

It was the same with artists. I love art and have made many photographs of artists. When the glass artist Dale Chihuly became famous, I shot pictures of him at his studio and at his exhibitions. This was before he surrounded himself with security men and publicity agents. We knew one another on a personal level. It was the same with Jacob Lawrence, one of the most important American artists of the Twentieth Century. I was impressed with his paintings depicting the history of African-Americans, so I called Lawrence to ask if I could take pictures of him. He invited me to his home studio. I took photographs at a number of his gallery openings, and we got to know each other.

I do my best work in a one-on-one situation rather than in among a pack of photographers. Group shoots are fun, but everyone gets the same pictures and our subjects invariably act differently--more formal. When a photo subject is not besieged, he or she will be more revealing. You see the personal side.

Introduction

A young rookie, BARRY SWEET, worked in Kansas at the *Topeka Capital Journal,* 1965-67.

I became interested in photography in 1960-61 when I joined the staff of the *Regent,* the student newspaper at West High School in Madison, Wisconsin. I was given a Speed-Graphic camera, which captured images on 4x5 negatives. My first break was being selected by the *Wisconsin State Journal* to attend a conference in Detroit where high school journalists competed for scholarships and sent news stories back to their hometowns describing the release of that year's new Ford models. This led to a part-time job as a copy boy at the *Journal,* where the photo staff took me under its wing and trained me as a photojournalist. The *Topeka Capital-Journal* saw my work and offered me a regular job in Kansas.

After a year of covering many tornados, among other things, I won an Associated Press photo contest for Kansas and Missouri newspapers. Then came an invitation to come to Kansas City for an interview and an offer of an AP photographer's job. I was given a choice of three cities. But the salary was disappointingly low, so I declined with thanks and went home to Topeka. A week later, I got a call from AP sweetening the offer and I accepted the job in Seattle in 1968.

I had no idea what to expect in Seattle. My parents thought I had moved to the end of the world. It was right next door to Alaska, you know. I was the only AP staff photographer west of Denver and north of San Francisco from 1968 to 1977.

Seattle was my home base, but many assignments took me throughout Alaska and the Pacific Northwest, to the South Pacific, and to many other destinations where news was breaking.

One of the first events I covered was the World Cup downhill ski competition at Crystal Mountain, Washington. This was a challenge for a young kid with no real experience. Then came the Apollo moon missions. The Apollo 8 capsules splashed down in the Pacific Ocean. Because the assignment required spending a month at sea, none of the AP photographers based in Los Angeles wanted the assignment, so I got it. This was good for my career. After that, I became AP's Apollo photographer and covered ten more missions in the Apollo 10 and Apollo 11 series.

I figure I made close to 100,000 images during my fifty years of photography. In those early years I traveled 50,000 miles a year on assignment pursuing "hard" news, sports, and features. The big stories included the Apollo 8 and Apollo 11 space missions; building of the trans-Alaska pipeline; many political campaigns, including the final days of Senator Robert Kennedy's campaign; the eruption of Mount St. Helen's; and a variety of sports events and teams—Super Bowls; NBA championships; Final Four college basketball tournaments; the Olympic Games in Canada; the Seattle Pilots; Seattle Mariners; and Seattle Seahawks.

The 1960s were full of turbulence, tragedy, and triumph. It was a time of restive students and restless Nature.

It was a decade in which Barry Sweet plunged into photojournalism, from the swirling cauldron of funnel clouds over Burnett's Mound in Topeka, Kansas to a spot in the Pacific Ocean marked only by coordinates of longitude and latitude, where the first men who had walked on the Moon returned to Mother Earth.

The decade was marked with social unrest, civil-rights marches, and anti-Vietnam war protests. It was a time of swiftly moving cultural change, of Woodstock, and Jimi Hendrix. The University of Wisconsin in Madison, Wisconsin, Sweet's hometown, was a hotbed of student activism and a coordinating center for anti-war demonstrations across the country.

On a happier note, Major League Baseball arrived in the Pacific Northwest. But it was a frustratingly brief appearance, sort of a one-night-stand by the Seattle Pilots, who after just a single season were moved to Milwaukee and renamed the Brewers.

1960s

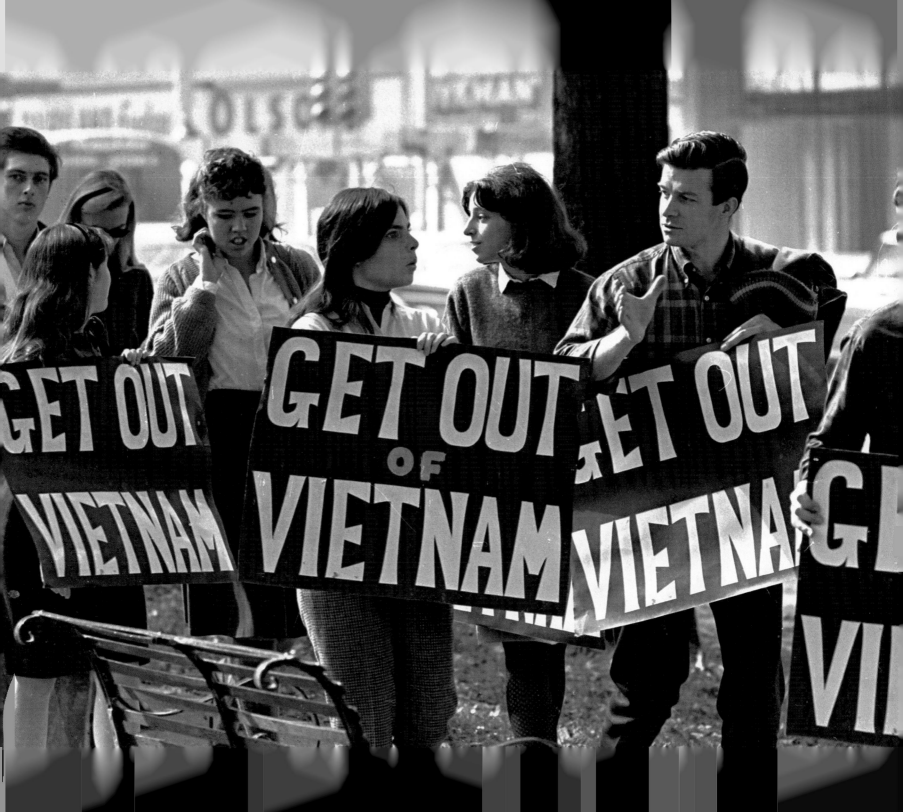

Protesting the war

In the mid 1960s, America became polarized by the Vietnam War. The anti-war movement fostered fledgling protests in 1964, which grew in strength through the decade, and spread across the United States and overseas. Initially the anti-war and peace movements mostly attracted young people, including college students and hippies, many concerned about the draft. Opposition to the war ranged from peaceful, nonviolent demonstrations to radical, in-your-face confrontations between police and protesters.

College campuses became the focal point of major unrest. Many of the student anti-war organizations were campus-based and local because they were easier to coordinate and participate in than national demonstrations. Anti-war demonstrations ranged from the burning of draft cards, to protests over campus job fairs by the military and by corporate interests supporting the war, to student protesters attacking military Reserve Officer Training Corps (ROTC) buildings on college campuses.

The protest movements began to die down in the early 1970s as the Nixon Administration negotiated its way out of an unpopular war.

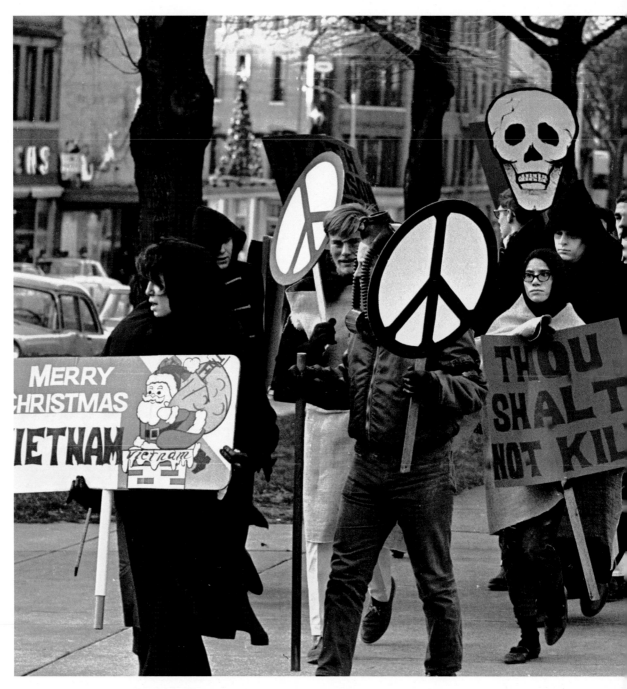

One of many protest demonstrations in 1965

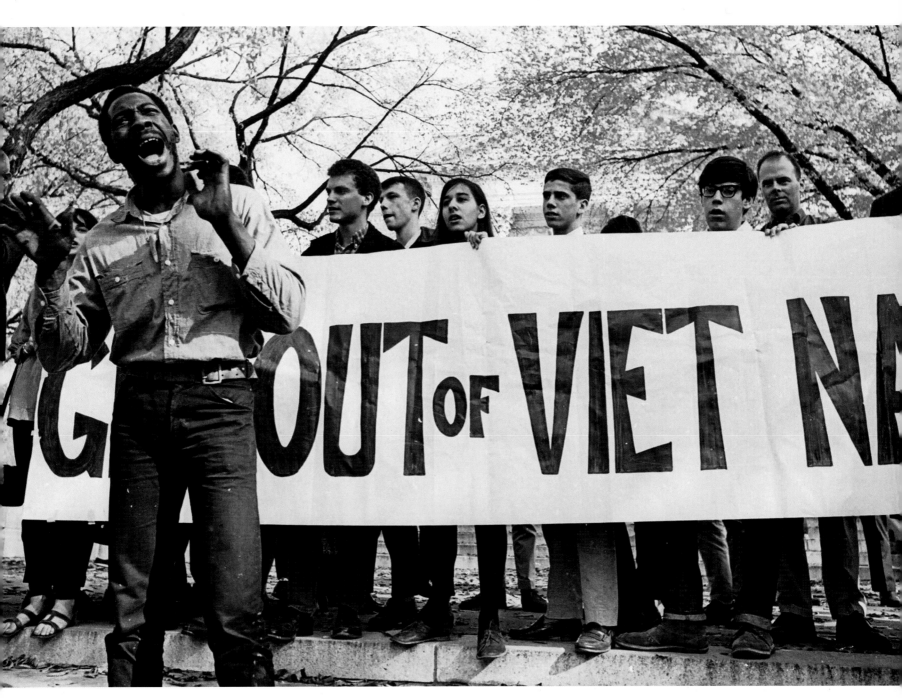

A protester exercises his freedom of speech in Madison, Wisconsin.

Anti-Vietnam war protesters march on the grounds of the State Capitol in downtown Madison, Wisconsin in October, 1965. The University of Wisconsin campus in Madison had become one of the centers for the organization of anti-war movement throughout the United States.

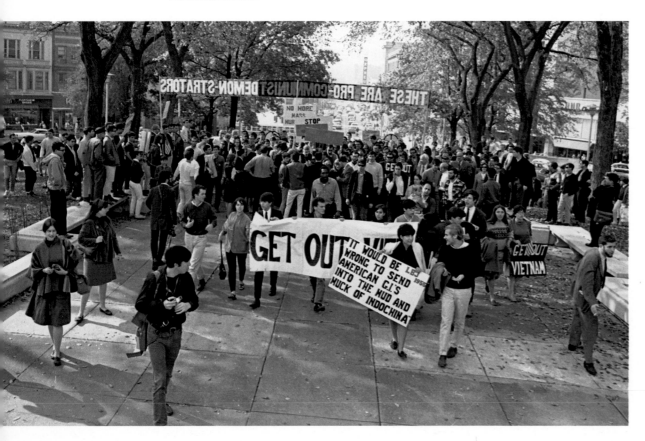

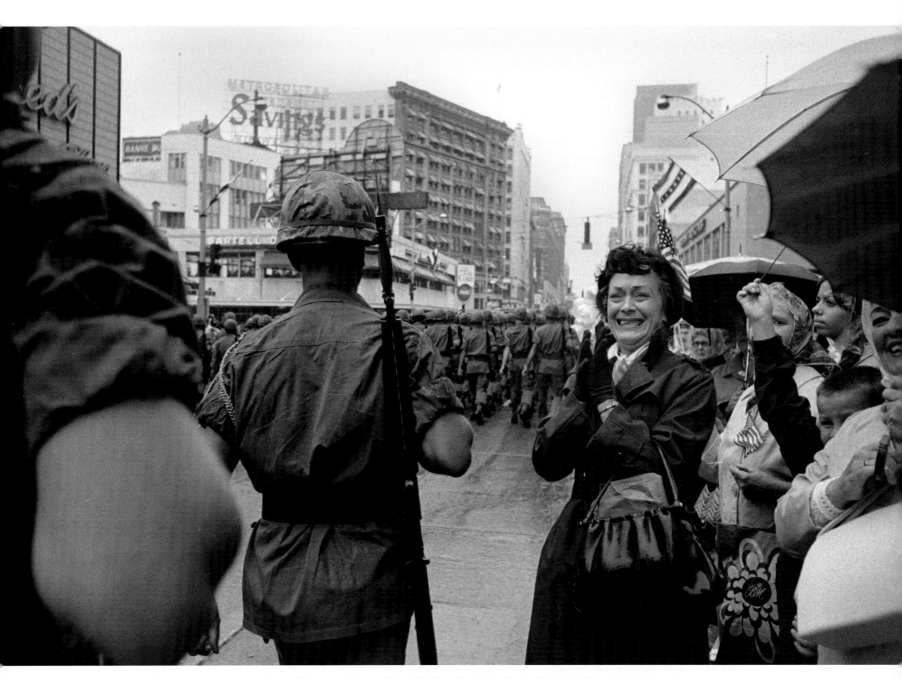

A woman is overcome by emotion as soldiers of the U.S. Army's 3rd Battalion, 60th Infantry parade through downtown Seattle in July, 1969. These troops were among the first brought home from the Vietnam war.

MARTIN LUTHER KING

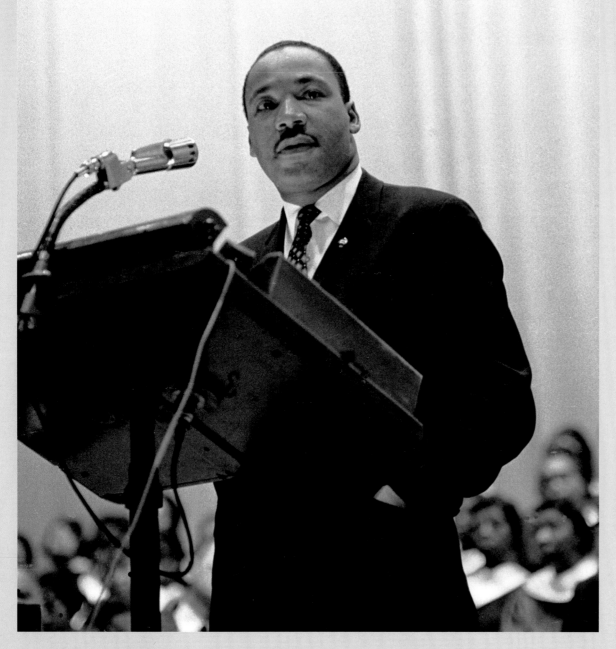

REV. MARTIN LUTHER KING JR., a leader of the American civil rights movement who fought for racial equality most of his life, addresses a Kansas audience in 1965. For his efforts King won a Nobel Prize for Peace in 1964. He was assassinated four years later.

Covering twisters in the Midwest

PERSPECTIVE

I was covering an outbreak of tornadoes in the Topeka area. It was raining like a son of a gun. My windshield wipers couldn't keep up with the deluge of water, I couldn't see a thing, and I was in the middle of nowhere. So I stopped the car, got out, looked up, and discovered I had parked underneath a large funnel cloud.

I was spared, but the tornado tore into a nearby farmhouse. Afterward, as I approached, an old fellow came out of the cellar carrying a piece of the basement door. He had lost everything.
"You know, this has happened to me before," he told me. "That's what happens when you live in this country."

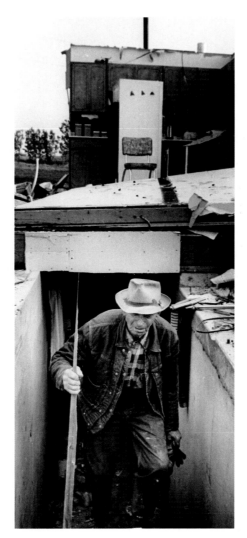

A Kansas farmer emerges from a cellar after a tornado destroyed his home.

MRS. JAMES KAUFMAN looks on in shock at the wreckage of her home destroyed in a tornado that swept through the Topeka, Kansas area on June 8, 1966.

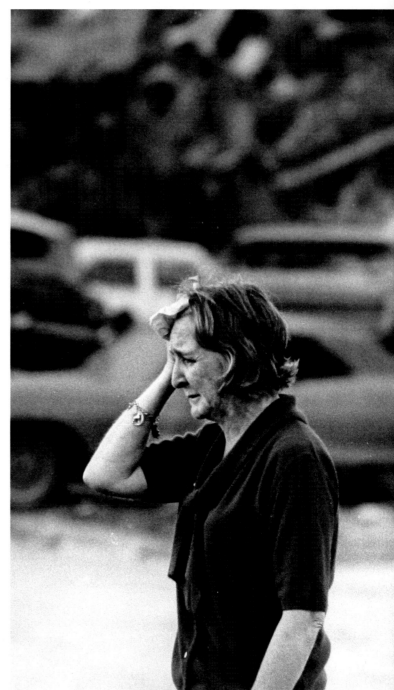

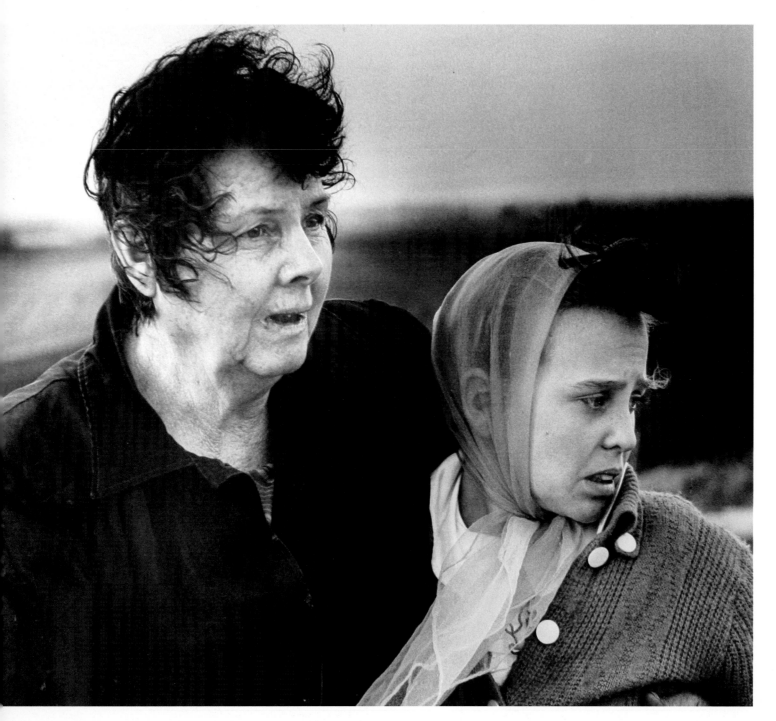

A woman and her child survey the wreckage of their home after the Topeka tornado.

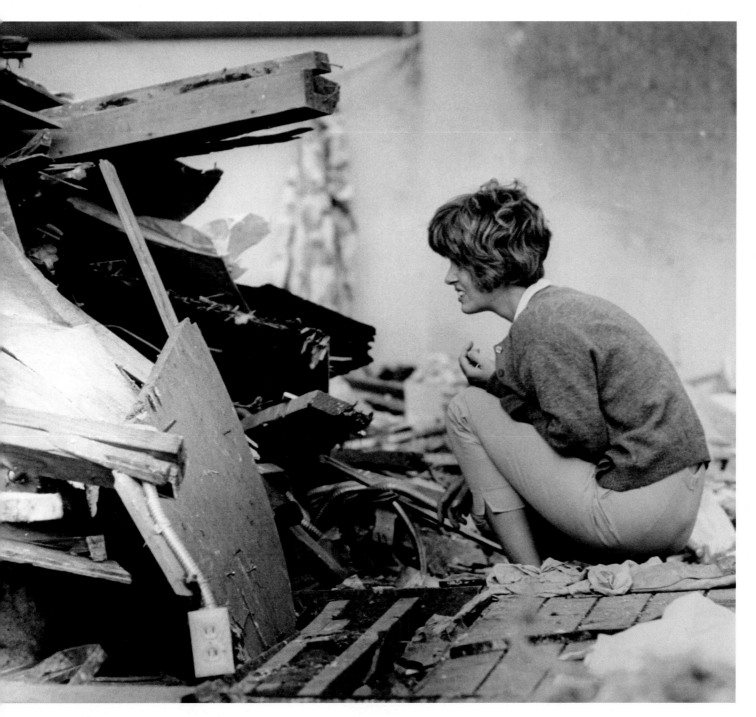

An unidentified woman peers into the wreckage of her apartment building, worried about having left her wedding ring on a dresser.

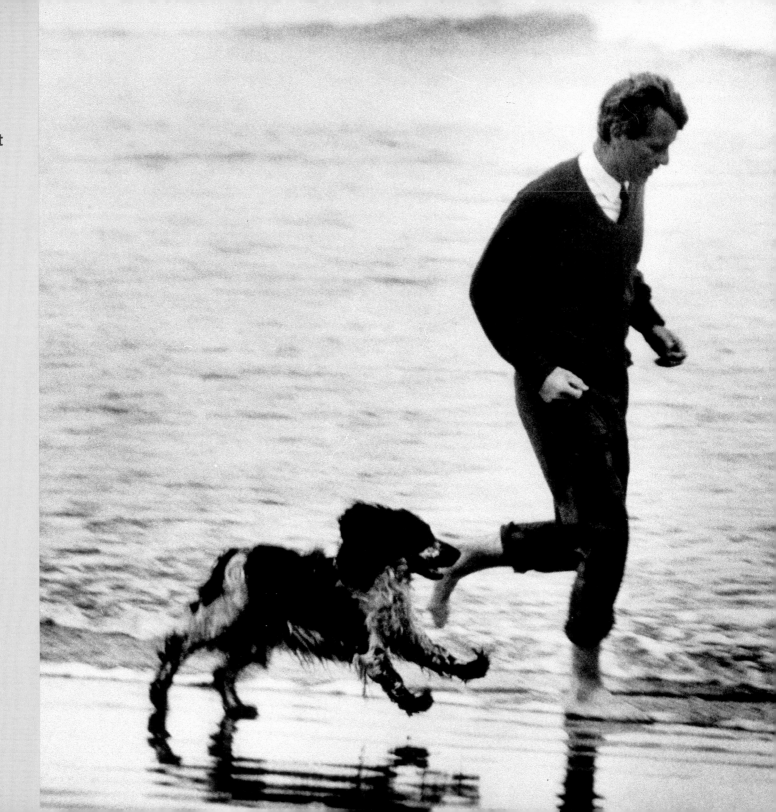

ROBERT F. KENNEDY

After I took this picture, Senator Kennedy asked the band of reporters and photographers covering him if we would give him some free time on the beach with his dog. We agreed. But when Kennedy returned, he told the reporters that he had stripped down to his underwear and waded into the surf.

This little tidbit of information found its way into news stories and of course every newspaper in the world wanted a picture of Bobby in his underwear. I had to tell the AP that I had no such photos. Did I ever get chewed out!

"Don't you ever do anything like that again," I was told. "If you're covering a politician, you stick by his side!" And I accepted that. A few days later Robert F. Kennedy was dead.

U.S. SEN. ROBERT F. KENNEDY runs with his dog, Freckles, through the ocean surf near Astoria, Oregon, on May 24, 1968, a day after losing the Oregon primary in his campaign for the Democratic presidential nomination. He went on to win the California primary on June 4, less than two weeks after this photo was taken. But he was assassinated that night at the Ambassador Hotel in Los Angeles.

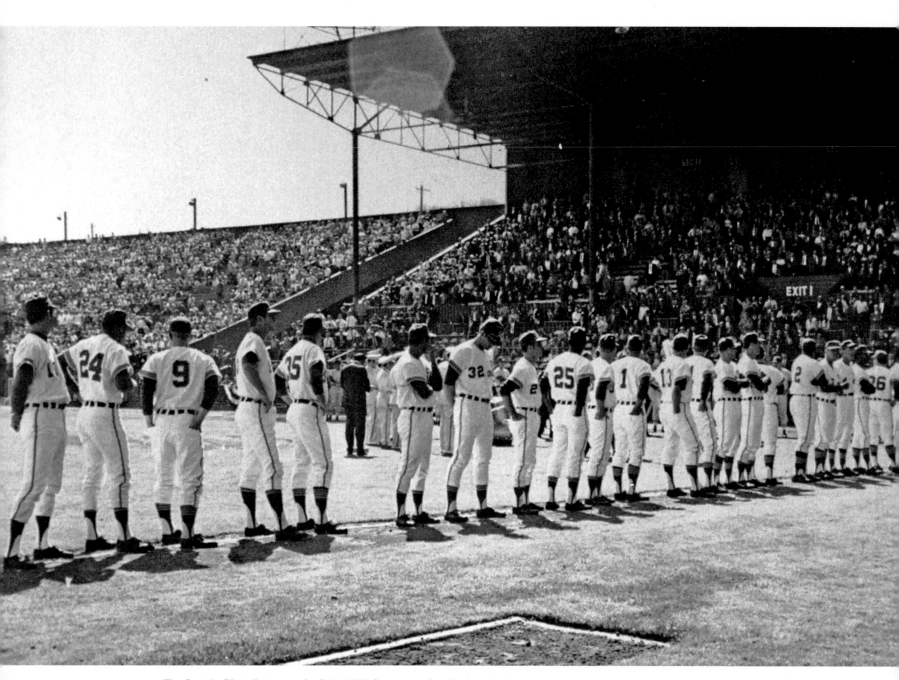

The Seattle Pilots line up on April 11, 1969 for an opening-day introduction
at Sicks Stadium before a game with the Chicago White Sox.

Here today, gone tomorrow

The Seattle Pilots, Seattle's first Major League Baseball team, began playing in 1969 but didn't last long. The very next year, the team was moved to Wisconsin and renamed the Milwaukee Brewers.

Several factors contributed to the move, which created an uproar in Seattle. Originally, the new franchise wasn't scheduled to begin play until the 1971 season, but pressure for early expansion of the American League accelerated the schedule by two years.

Seattle was not ready. Sicks Stadium did not meet Major League Baseball standards. Plans were made to expand the facility to 30,000 seats, but only 17,000 seats were ready for opening day. Attendance was so poor that the Pilots owners and management faced a financial crisis by the end of the season.

Seattle Pilots Manager JOE SCHULTZ on the pitcher's mound at the old Sicks Stadium, home of the Seattle Pilots, who played in the city one season.

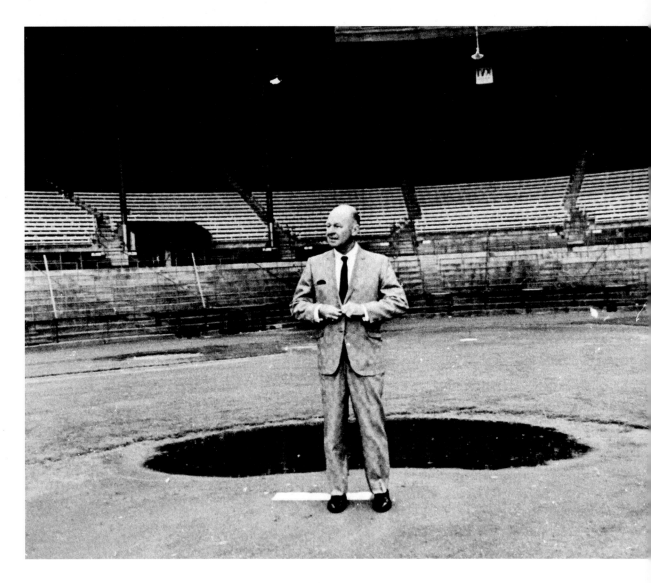

PERSPECTIVE

Sicks Stadium was a minor-league stadium. There were no camera positions on the field. We couldn't take pictures from the ground level. All the pictures were taken from the roof, which we reached climbing ladders.

The darkroom underneath the stadium had a dirt floor! Imagine the challenge of processing film and printing photographs amid clouds of dust. The negatives were scratched. The pictures were dirty. That's why there are so few pictures left of the Seattle Pilots. Most of the dirty negatives were destroyed.

Apollo 11 splashdown

Apollo 11 was launched from Kennedy Space Center in Florida on July 16, 1969. It was the first mission to land a man on the Moon, fulfilling the late President John F. Kennedy's goal of reaching the lunar surface by the end of the 1960s. Apollo 11 was the fifth manned mission of the Apollo program and the third lunar mission.

Astronaut Neil Armstrong's first words upon becoming the first human to set foot in the Sea of Tranquility on the Moon's surface became an instant entry in the history books—"That's one small step for man; one giant leap for mankind."

Astronaut Edwin "Buzz" Aldrin Jr. was in the lunar-lander module with Armstrong and later set foot on the Moon's surface as well. Meanwhile, Astronaut Michael Collins, the Command Module pilot, remained in lunar orbit while Armstrong and Aldrin made their historic expedition to the surface. Five additional Apollo missions made lunar landings between 1969 and 1972.

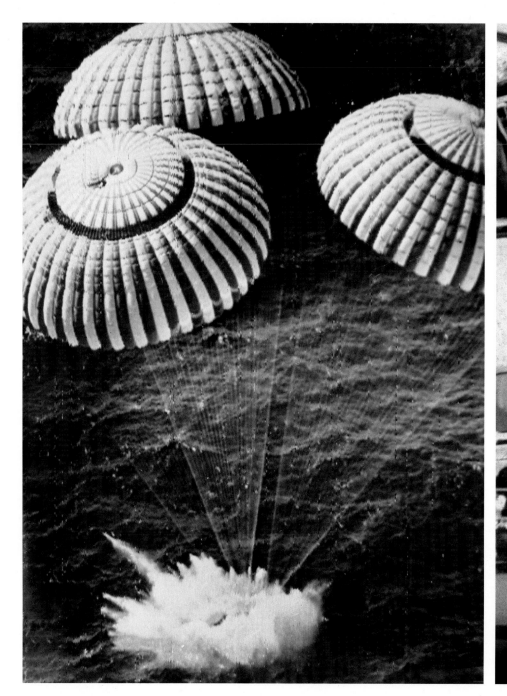

Apollo 11 splashes down in the Pacific Ocean on July 24, 1969

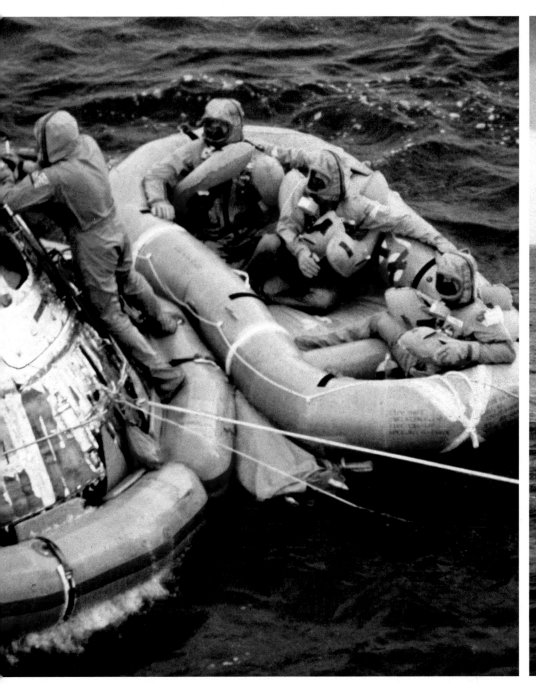

The astronauts await a helicopter pick-up after their return to Earth.

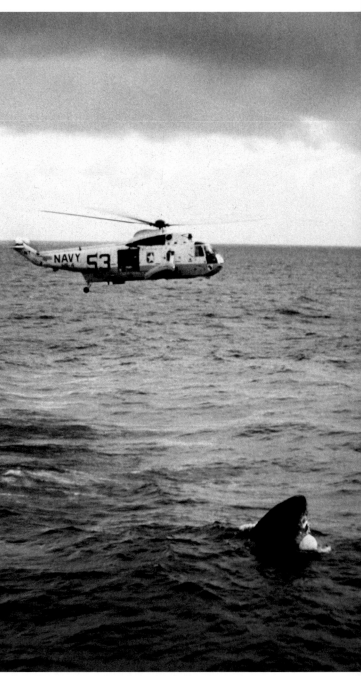

The astronauts leave their space capsule behind as a Navy recovery helicopter flies them to the *U.S.S. Hornet*.

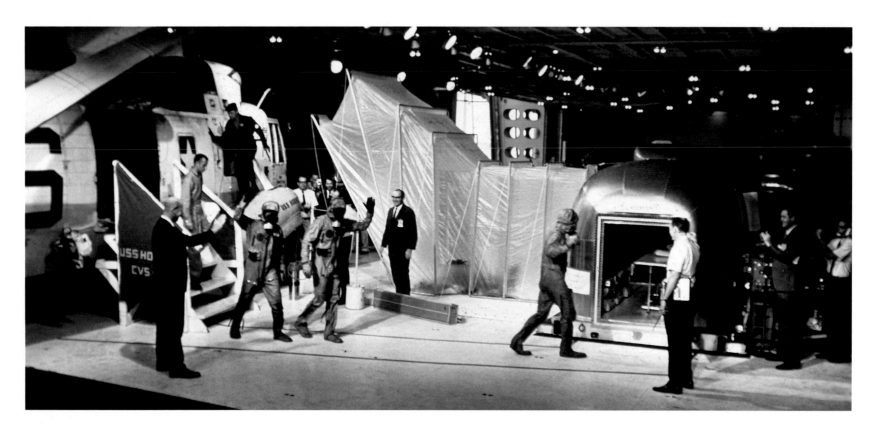

PERSPECTIVE

A turf war broke out among the press photographers when President Nixon flew out to greet the returning astronauts aboard the aircraft carrier U.S.S. Hornet. Photographers with White House credentials traveled with the President, and right away questions arose as to who would take pictures of the President and who would photograph the ocean recovery.

Basically the White House photographers wanted it all. Needless to say, this did not sit well with photographers, including me, who had NASA credentials and had been at sea for nearly a month awaiting this photo opportunity. The White House photographers were one-day wonders flying in and out with the President.

The NASA photographers did not want White House photographers to transmit their photos out to the world on the Navy's radio-communications network, which had been designed for our exclusive use. We told the powers-that-be that NASA photographers would boycott the event altogether if the outside photographers were allowed to intrude.

"We'll sit on the flight deck and watch it," we told NASA.

We insisted that when the White House photographers left the ship, they should take their film with them. We got our way. This meant we had a twelve- to fourteen-hour break getting our pictures on the wire before the White House photographers would be able to develop their film. By then, our pictures would have been transmitted worldwide.

Apollo 11 crew members, from left, **MICHAEL COLLINS, EDWIN "BUZZ" ALDRIN JR.,** and **NEIL ARMSTRONG** enter the MQF (Mobile Quarantine Facility) aboard the *U.S.S Hornet* after their recovery from the space capsule in the Pacific.

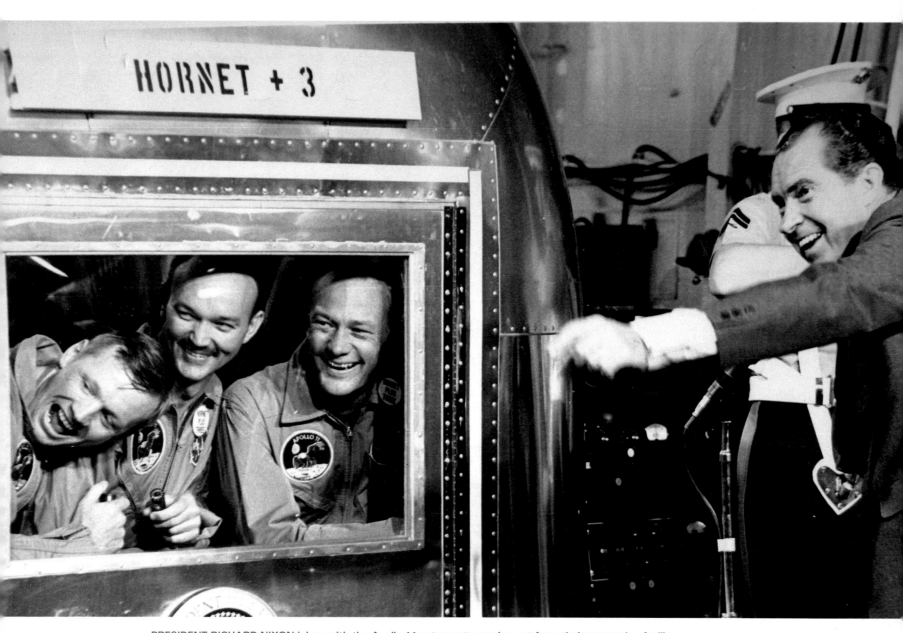

PRESIDENT RICHARD NIXON jokes with the Apollo 11 astronauts peering out from their quarantine facility.

The 1970s were a decade of highs and lows for the Puget Sound region--in business, politics, and sports.

The Boeing Bust sent Seattle's economy spiraling downward and gave a new meaning to the words "Skid Road." The company's workforce plunged from a high of 103,000 employees to about 39,000. The company's plans to build a supersonic transport (SST), of which the region was so proud, stalled and design work was scrapped altogether when the government cancelled funding in 1971.

Things were so bad that a billboard near Seattle-Tacoma International Airport became an unhappy symbol of the economic woes, asking, "Will the last person leaving SEATTLE Turn out the lights?" The lights flickered, but did not go out.

In politics, one of the most popular governors was succeeded by one of the most controversial. Dan Evans, who had served three terms, was succeeded in 1977 by Democrat Dixy Lee Ray, who so aggravated the press, public, and even her own party that she lost the Democratic primary in a bid for re-election in 1980.

Senator Henry M. "Scoop" Jackson, one of Washington state's two powerful U.S. senators, made two runs for the presidency, seeking the Democratic nomination in 1972 and again in 1976. It was not to be.

In sports, the Seattle Pilots, the Major League Baseball team that the city had campaigned to get for so long, moved to Milwaukee. That left the city with a single professional team, the Seattle Supersonics of the National Basketball Association.

1970s

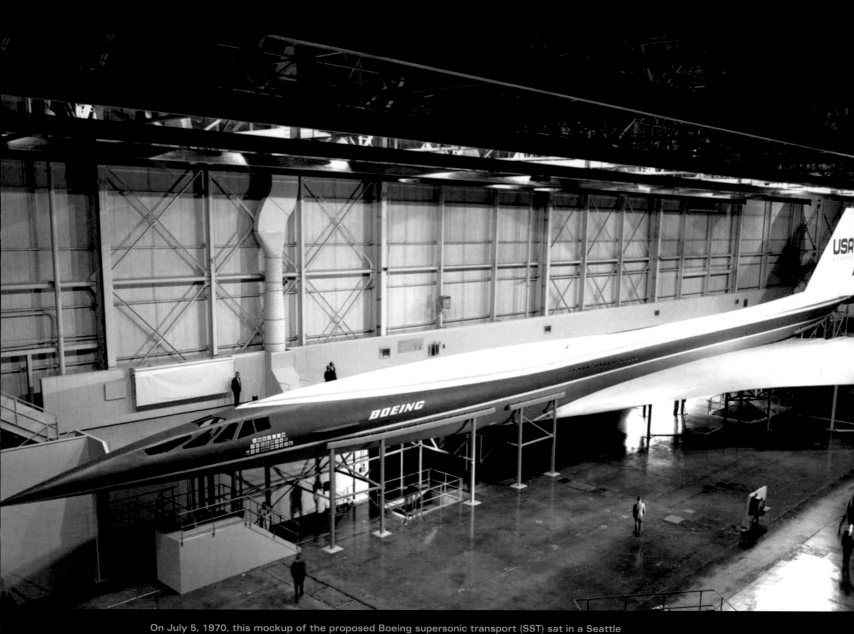

On July 5, 1970, this mockup of the proposed Boeing supersonic transport (SST) sat in a Seattle hangar, a model of a plane that was never built. Boeing had been selected by the federal government to build a prototype following more than fourteen years of study, design work, and competition within the aerospace industry. After its selection, Boeing presold 122 SSTs to twenty-six airlines, but Congress killed the project in May, 1971.

By the middle of the decade, however, the sports scene improved. In 1974, the city was granted a franchise for a National Football League team--the Seattle Seahawks--with majority ownership held by the well-known Nordstrom family. The Seattle Kingdome was opened in 1976.

Meanwhile, a lawsuit against the American League for breach of contract for the loss of the Pilots led to establishment of another expansion team, the Seattle Mariners, in 1977. Seattle also received a franchise in the new North American Soccer League for the Seattle Sounders in 1974.

Soon sports fans' cups overflowed.

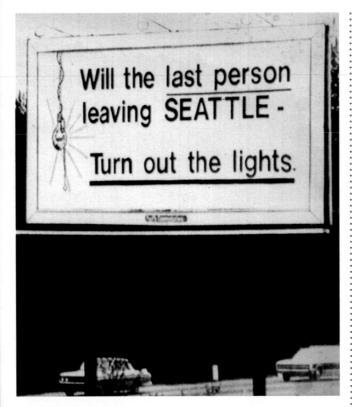

This billboard materialized in Seattle when the city's economy crashed in what became known as the "Boeing Bust." On March 24, 1971, the U.S. Senate voted to eliminate funding for the Boeing supersonic transport plane (SST). The same day, Boeing announced that it would terminate 7,000 jobs. That was just the beginning of layoffs. Seattle's unemployment hit 25 percent before the worst was over.

Trial of the Seattle Seven

Members of the radical Seattle Liberation Front and other anti-Vietnam war protesters take part in a demonstration that turned violent outside the U.S. Courthouse in Seattle on February 17, 1970. A federal grand jury indicted eight members of the SLF on charges of inciting the February riot. One disappeared and the others became known as the "Seattle Seven." At their trial in November, a mistrial was declared after the proceedings were disrupted by the defendants, who were cited for contempt of court, found guilty, and served three months in jail. Eventually the original charges were dropped.

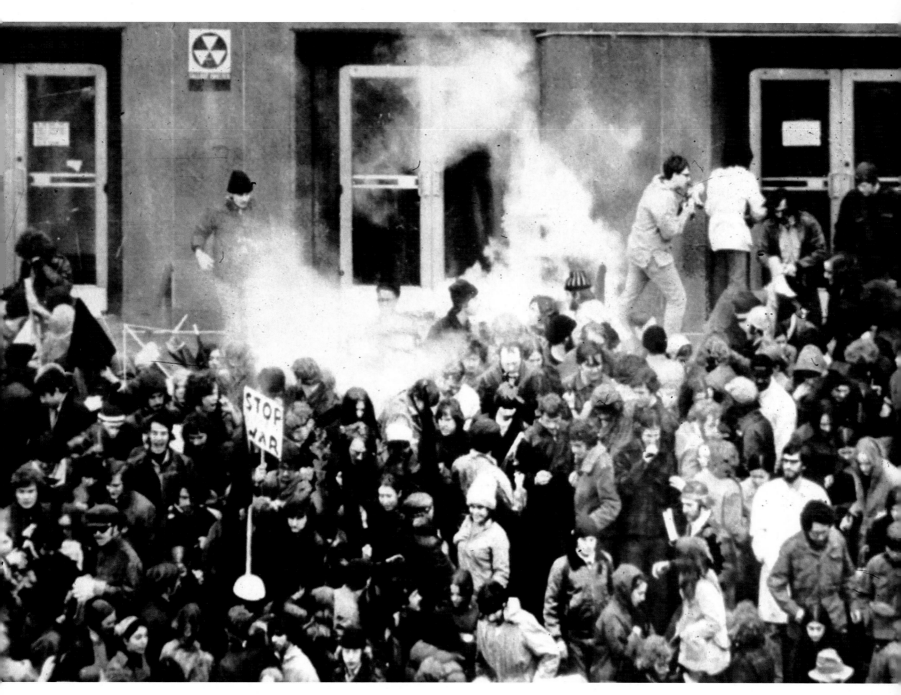

Seattle Seven outside the U.S. Courthouse in Seattle February 17, 1970.

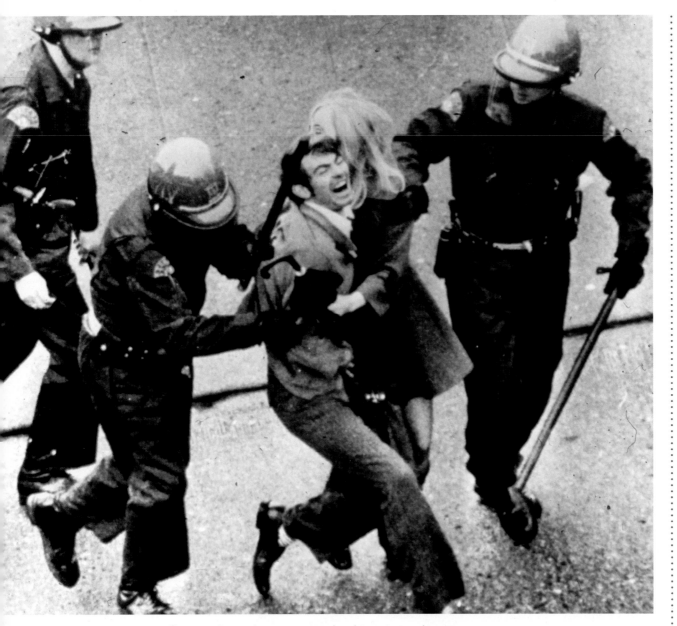

JIMI HENDRIX

The body of rock legend JIMI HENDRIX is carried from Dunlop Baptist Church in Renton, Washington following a private funeral on October 1, 1970. Escaping from a difficult home life into the music world, Hendrix had gotten his first guitar at age fifteen and went on to became a guitarist, singer, and songwriter, playing backup for such performers as Little Richard and Sam Cooke. In the late 1960s, his manager, Chas Chandler, persuaded Hendrix to go to London, where he found international success and earned the admiration of the Beatles, the Rolling Stones, the Who, and Eric Clapton. Hendrix died in London on September 18, 1970, from drug-related complications. He was only twenty-seven.

Seventy-six people were arrested and twenty people were injured when a protest demonstration turned into a riot outside the U.S. Courthouse in Seattle.

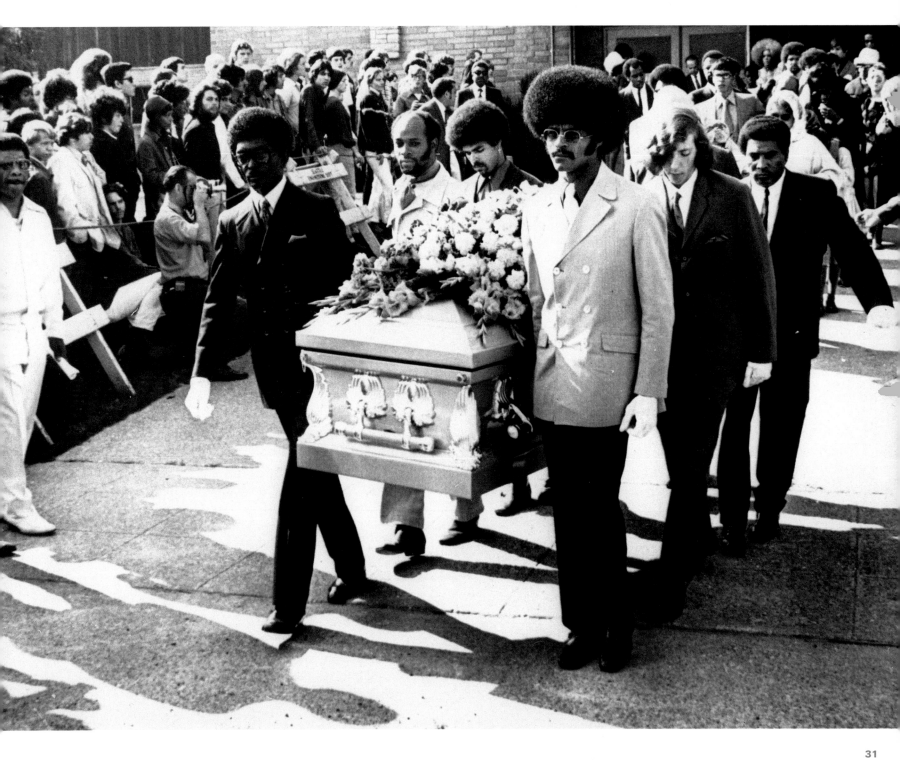

A popular "Straight Arrow" governor

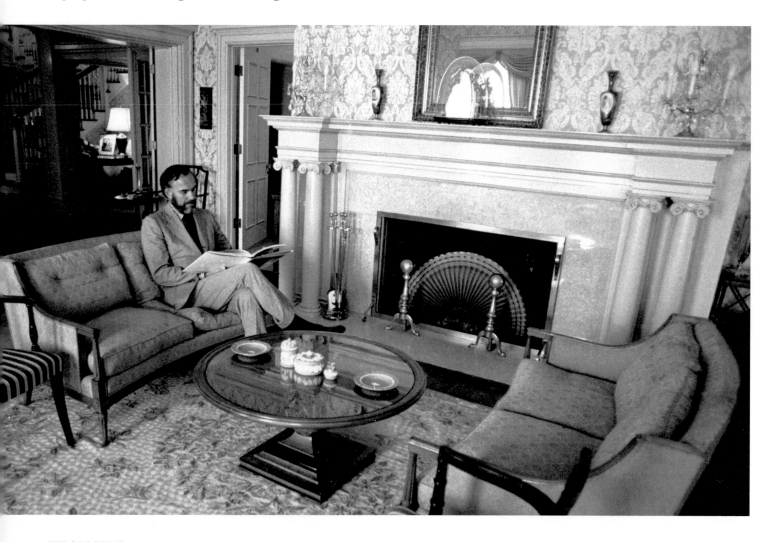

GOVERNOR DAN EVANS at the governor's mansion in 1970

Washington GOVERNOR DAN EVANS, whose nickname was "Straight Arrow," pauses for a picture during a snowfall outside the Capitol in Olympia in 1972. The popular three-term Republican governor was appointed to the U.S. Senate in 1983 upon the death of Senator Henry M. "Scoop" Jackson. Evans' political career began with his election to the Washington House of Representatives in 1956.

PERSPECTIVE

In the days when a journalist's relationships with newsmakers were important, I had great access to Dan Evans.

It was this professional friendship that opened the doors to making several interesting pictures of him. The one in the snowstorm was one of them. We were just leaving his office.

He had an umbrella out to keep off the snow, and we walked down the steps together. Most of the time his only security was a state trooper.

The security for public figures is so tight now that you cannot get near them.

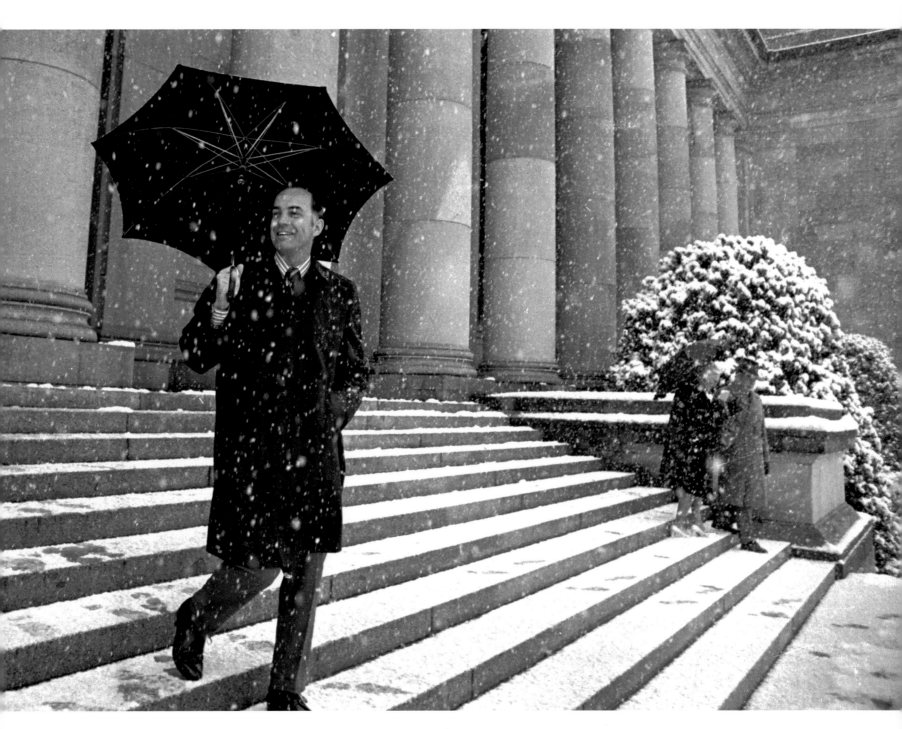

The Alaska oil boom

In 1968, Atlantic Richfield discovered a major oil deposit at Prudhoe Bay, Alaska on the Arctic Ocean. Three years later, a consortium of oil companies with interests in the region prepared to begin construction of an 800-mile pipeline from Alaska's North Slope to Valdez on the Gulf of Alaska. However, the project was delayed for three years awaiting resolution of legal challenges from Alaska Natives and conservationists. Construction began in 1974 after an oil crisis caused shortages and sharp increases in U.S. oil prices, and the first barrel of oil was put into the pipeline in 1977.

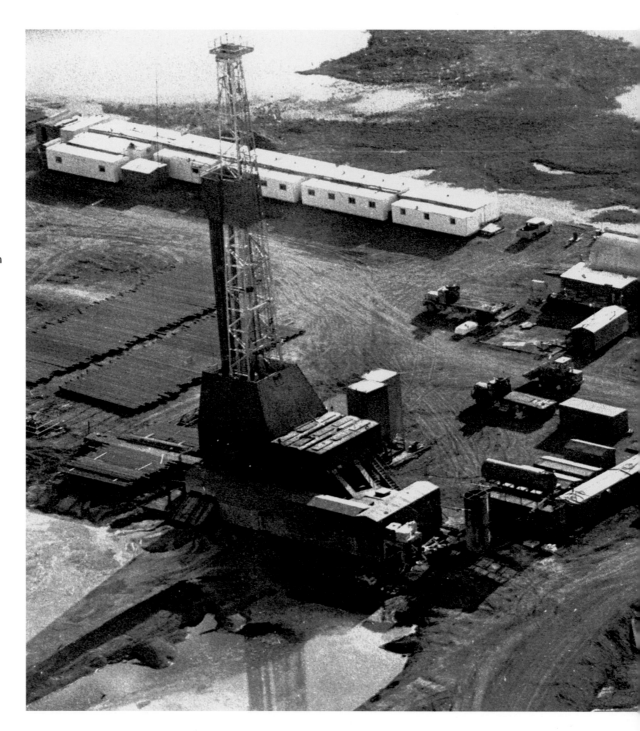

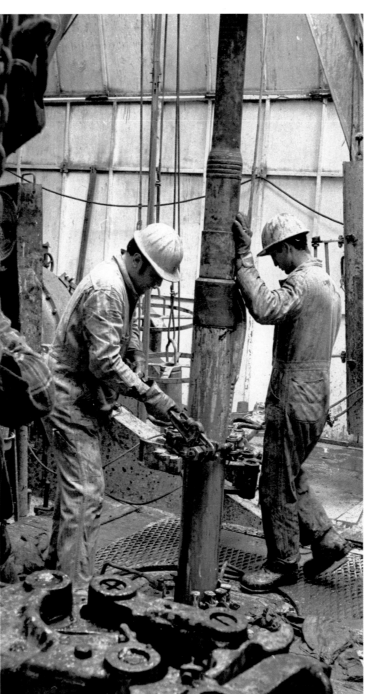

PERSPECTIVE

When we went to Alaska to shoot pictures of construction in the North Slope oil field we encountered conditions no one expected.

In minus 30-degree temperatures you couldn't take a picture and then advance the roll because the film would become brittle in the cold and splinter. So you had to go out into the cold and shoot a single photo, return to a warm truck or building, allow the camera to warm to room temperature, advance the film one frame, and then go back outside and take another picture, repeating the whole process.

This made me think of Civil War photography--one shot, one slide, one picture. Brrrr!

Roughnecks drill for oil on a rig at Prudhoe Bay on Alaska's North Slope field in 1971. North Slope crews typically worked two weeks on and two weeks off, laboring long hours seven days a week on the slope and then flying home to Anchorage, Fairbanks, and cities in the Lower 48 for two weeks of rest.

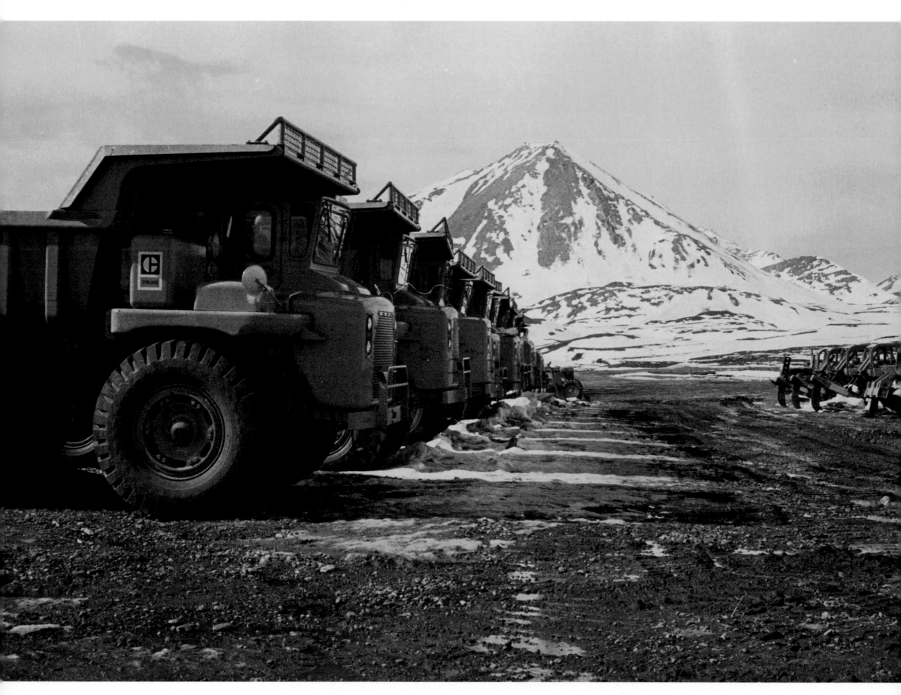

Heavy equipment sat idle awaiting a green light for pipeline construction to begin.

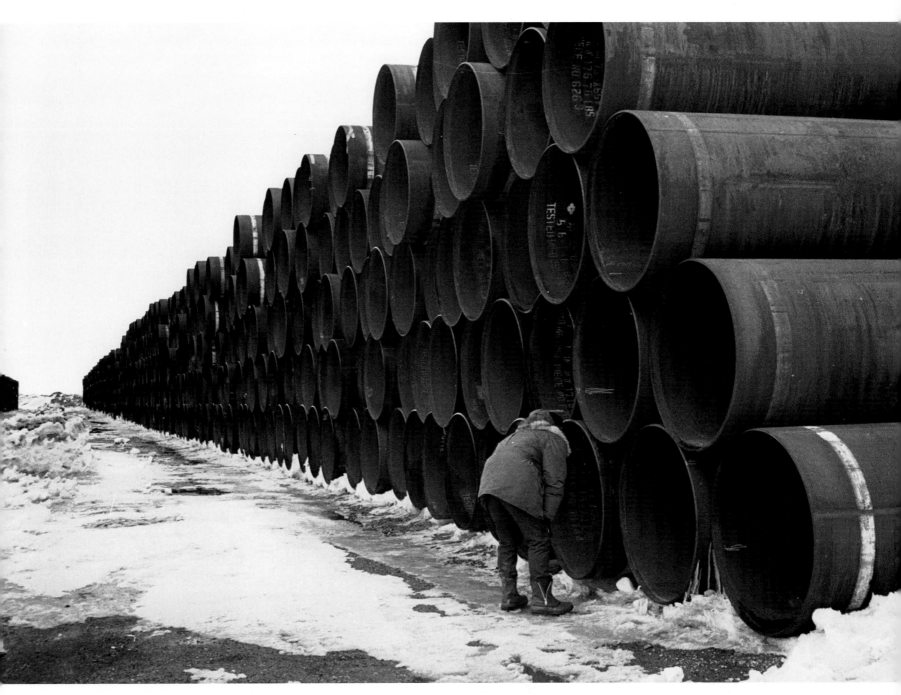

Stacks of 48-inch steel pipe await construction of the trans-Alaska pipeline in 1971.

PERSPECTIVE

I met Dixy Lee Ray when she was head of the Pacific Science Center in Seattle, where I used to go to dig up a lot of good feature photos.

When she announced she was going to run for governor, the news editor told me to get a picture of her. When I called Ray, she said sure, and jumped into her Jeep and drove over to the AP office, proving once again that relationships created good photo opportunities.

After she became governor, I began getting calls alerting me that Ray was going to drive a logging truck in Aberdeen, or would be riding in the engine of the visiting Royal Canadian train, or something or other. She loved doing unconventional things. Throughout her career I shot several front-page pictures of her doing them!

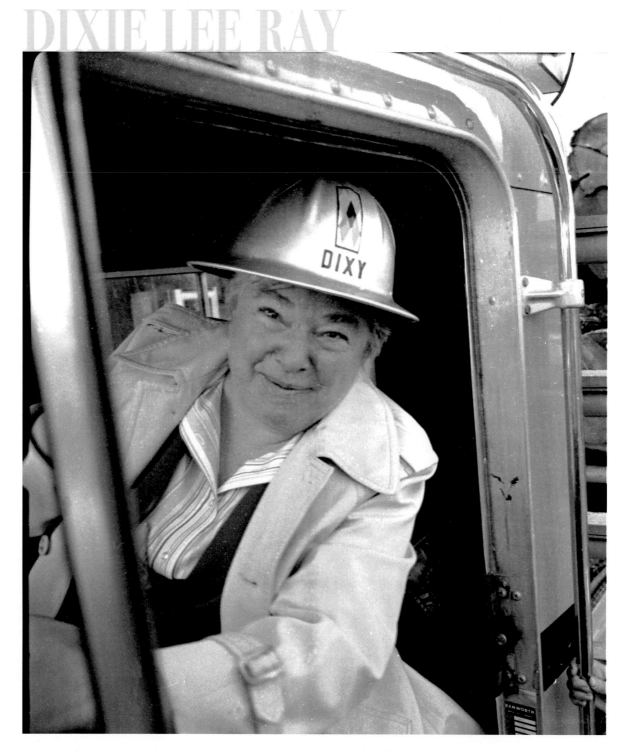

Washington GOVERNOR DIXY LEE RAY sits behind the wheel of a giant logging truck during a visit to the Grays Harbor County Fair in Aberdeen in 1977. Ray, a Democrat, was elected Washington's first woman governor. Once in office she became so controversial that she was unable to get her party's nomination for a second term in 1980.

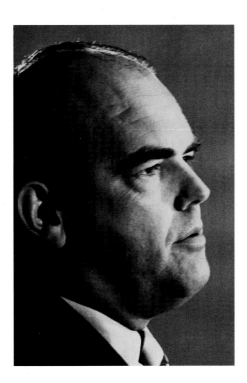

John Ehrlichman at his Seattle home in 1973. A native of Tacoma, Ehrlichman was counsel and assistant to the President for domestic affairs under President Richard Nixon. Because of his role in the Watergate break-in and scandal, Ehrlichman resigned his post in April, 1973 at Nixon's request. He was convicted of conspiracy, obstruction of justice, perjury, and other charges in January, 1975 and served eighteen months in federal prison. He died in Atlanta in 1999.

JOHN ERLICHMAN at home 1973

JOHN EHRLICHMAN

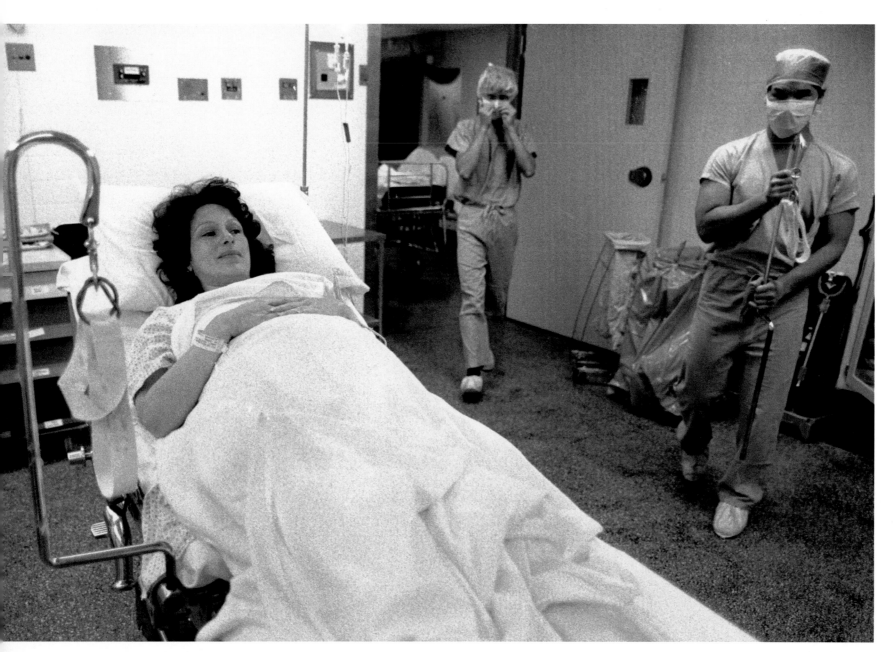

BARRY SWEET was there with his camera when his wife, Raleigh, was wheeled into a delivery room at Virginia Mason Hospital in Seattle to give birth to their first child, Corrie, on March 14, 1976.

A photo shoot close to home

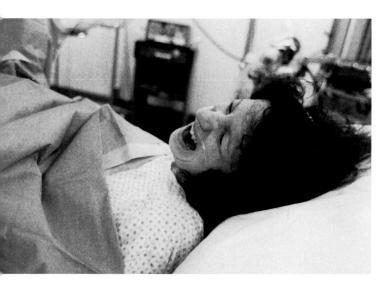

PERSPECTIVE

Because of my profession and friendship with the doctor, I was given permission to take pictures when our daughter Corrie was born. The doctor got so involved that there were moments when he ignored Raleigh while helping me to find the best angles for pictures.

I had wanted to do this after seeing the great photos that Brian Lanker made of a child birth that won a Pulitzer Prize. Because this was our first child, Raleigh and I became deeply involved in the process. I also made photos of my second child, Jason.

Doctors and nurses help RALEIGH SWEET deliver her baby girl. In the mid-1970s, it was uncommon for husbands to be present at birth, let alone photograph it.

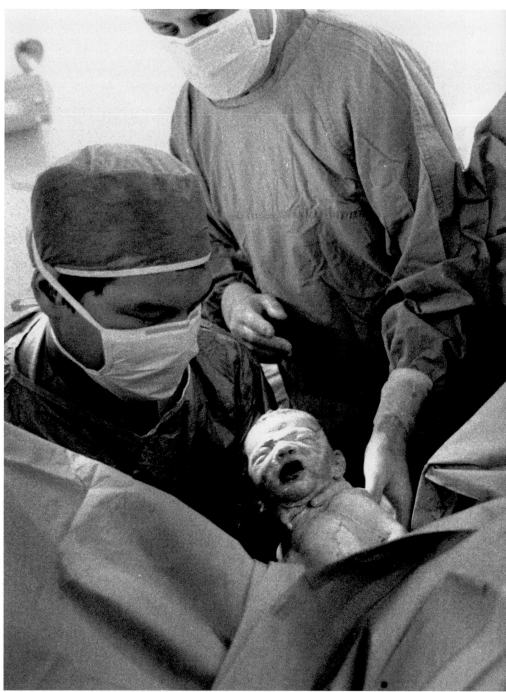

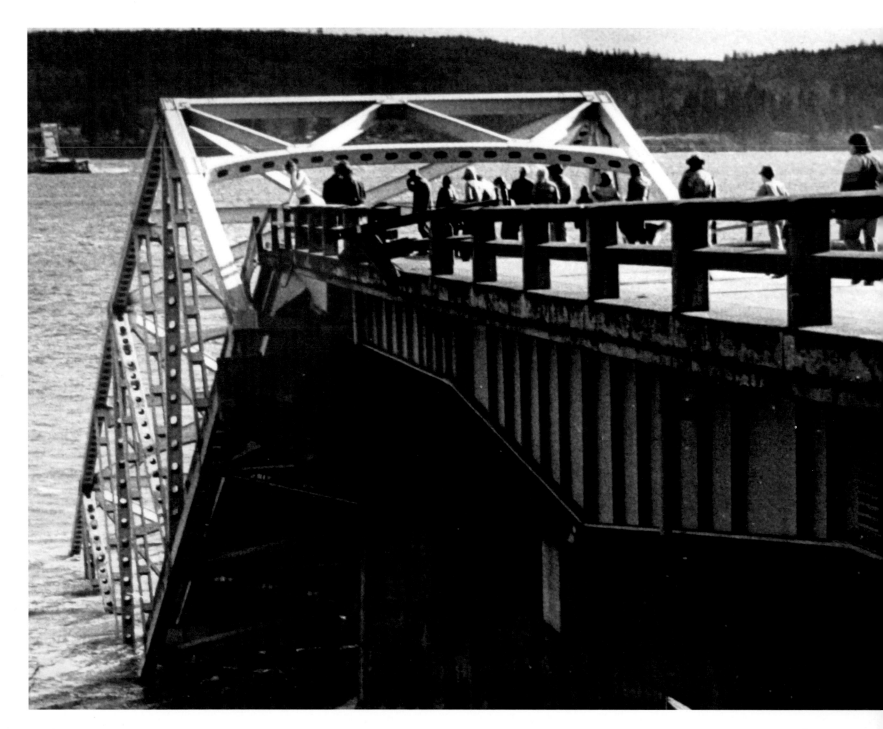

Fierce storm sinks floating bridge

Less than twenty years after it was built to connect Washington's Olympic and Kitsap peninsulas, the Hood Canal Bridge suffered a catastrophic failure in 1979 during a storm that pounded it with winds of 85 mph and gusts to 120 for several hours. At 7 a.m. on February 13, pontoons on the western side of the 1.2-mile floating bridge broke loose and sunk. The bridge had been evacuated. The pontoons were thought to have been flooded when hatches were blown open. The bridge was rebuilt with federal funds, reopening in 1982.

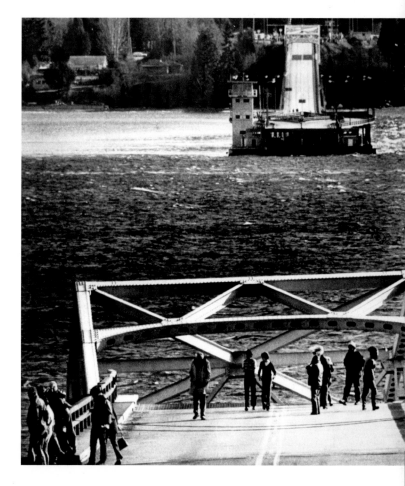

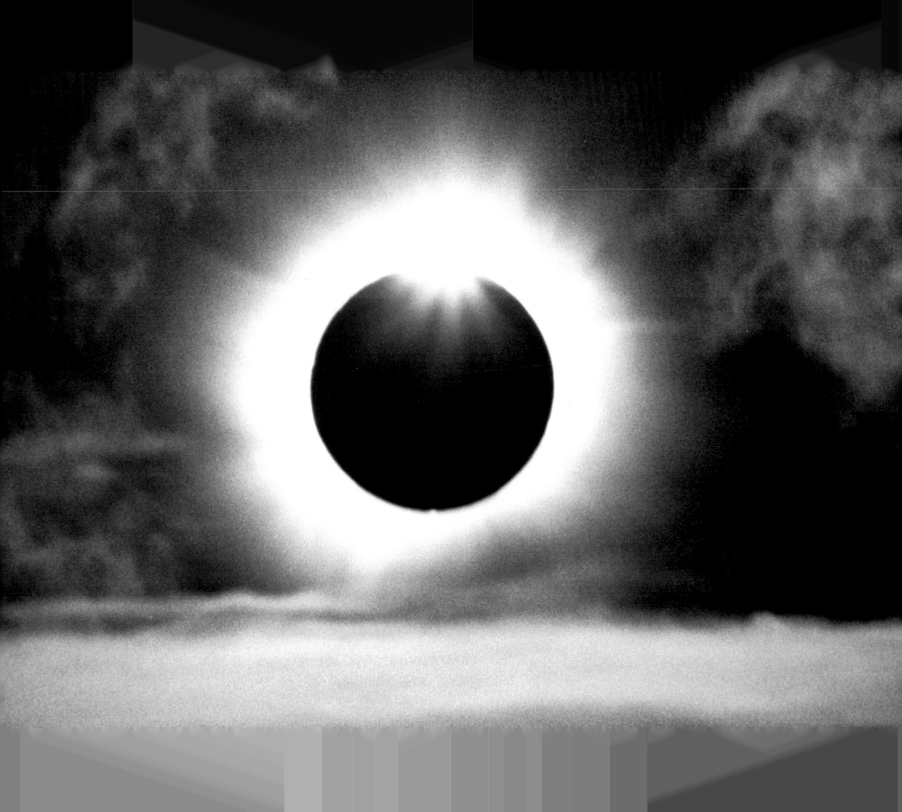

Faces in the crowd

Writer TOM ROBBINS, photographed at his home in La Conner, Washington in 1976, is best known for his novel *Even Cowgirls Get The Blues*, which was made into a movie. Robbins grew up on the East Coast but moved to Seattle in 1962 to attend graduate school at the University of Washington. During the 1960s he worked as an art critic for the *Seattle Times*, wrote a column for *Seattle* magazine, and hosted a weekly "underground" radio show. He moved to La Conner in 1970.

PERSPECTIVE

Seattle was blocked by clouds the day of the solar eclipse so I thought I would head south to see if I could find better conditions for getting photos.

Outside of Olympia I got a flat tire. It wasn't looking good. If I missed this, I would have to wait several decades for another opportunity to shoot a total eclipse of the sun. So I called a repair service, and while the guy was fixing my flat—low and behold!—the clouds parted and there it was. I quickly got out my gear from the trunk, set up a tripod, and made a series of pictures including this one.

Minutes later the clouds returned, and that was it.

TOM ROBBINS

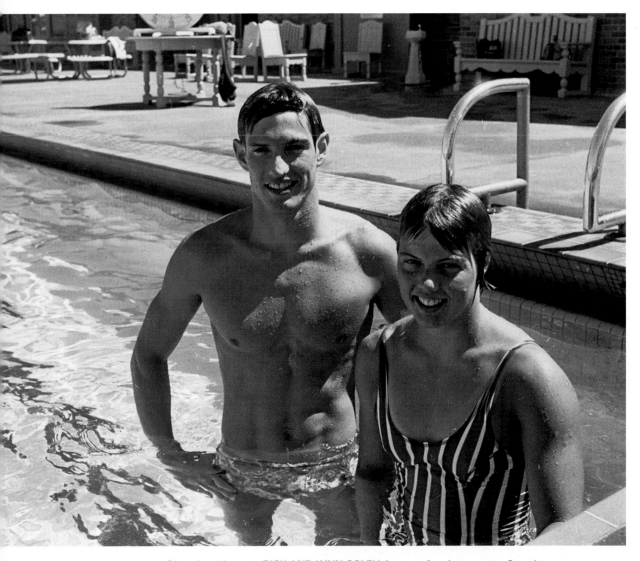

DAVE BECK, a former president of the Teamsters Union and American labor union leader, relaxes in his Seattle apartment during his retirement. In 1957, Beck retired following an appearance before a U.S. Senate committee where he was interrogated by committee counsel Robert F. Kennedy about union activities. He invoked the Fifth Amendment. In 1959, he was prosecuted for embezzlement and labor racketeering in Washington state and later was convicted on federal income-tax evasion charges. He served thirty months in prison and died in 1993.

Olympic swimmers RICK AND LYNN COLELLA pause for pictures at a Seattle pool in 1971, while training for the 1972 Olympic Games, where Lynn won a silver medal in the women's 200 meter butterfly. Brother Rick won a bronze medal in the breaststroke in the 1976 Olympics. The Seattle siblings also earned medals in the World Championships, Lynn in 1973 and Rick in 1973 and 1975.

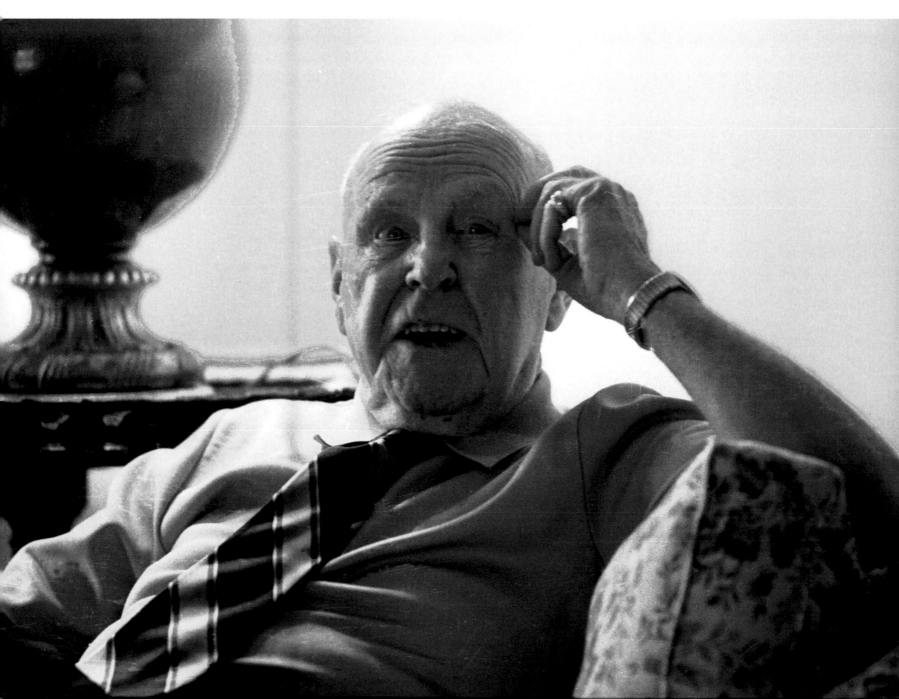

DAVE BECK

SEATTLE MAYOR WES UHLMAN in his office in December, 1974. Uhlman served as Seattle mayor from 1969 until 1977, turbulent years of protest and change. During his terms he reorganized city government for increased efficiency, broadened social-service programs, and encouraged citizen participation in local government.

On May 1, 1976 a weary SENATOR JACKSON tells supporters and reporters at a news conference that he is ending "active pursuit" of the Democratic nomination for President after his second run for the presidency. Jimmy Carter won the Democratic nomination that year and went on to the White House.

SENATOR WARREN G. MAGNUSON, right, sits with Dr. Bill Hutchinson at a ground-breaking for the Fred Hutchinson Cancer Research Center in Seattle on August 23, 1973. Doctor Hutchinson founded the center in honor of his younger brother, a longtime Major League Baseball pitcher and manager.

WARREN G. MAGNUSON

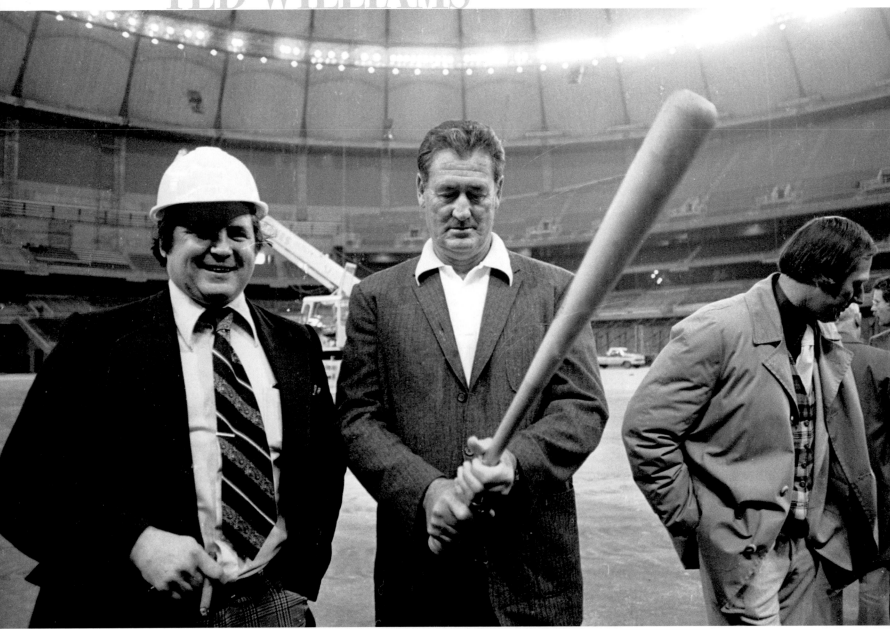

It was only natural that baseball Hall of Famer TED WILLIAMS, center with bat, would take batting practice before the 1976 opening

of the Seattle Kingdome, home of the Seattle Mariners for nearly a quarter of a century. Williams was baseball's last .400 hitter,

having hit .406 in the 1941 season. He was said to have such good eyesight he could see individual stitches on a pitched ball.

Professional bowler EARL ANTHONY reflects during an interview in his hometown of Tacoma in 1975 on his long career when the sport was a major fixture on television and in the newspaper. Anthony won forty-three titles, including six Professional Bowlers Association national championships, and was named Bowler of the Year six times. He bowled perfect 300 games twenty-five times. He died in 2001.

EARL AVERILL

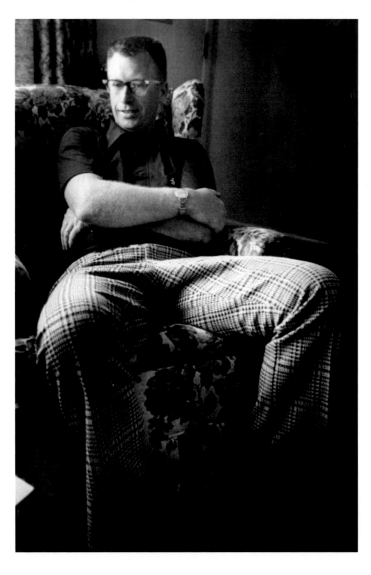

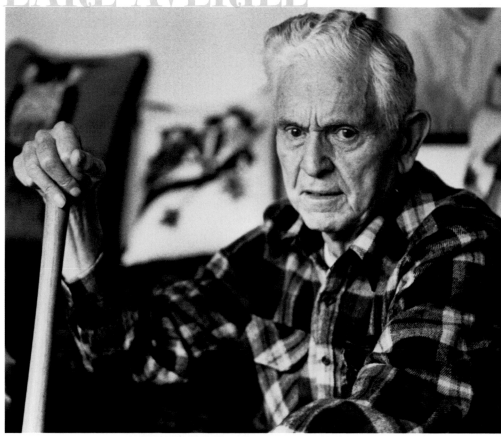

Baseball Hall of Famer EARL AVERILL, "The Earl of Snohomish," was photographed at his home in Everett in 1975. Averill played centerfield for the Cleveland Indians from 1929 to 1939, for the Detroit Tigers in 1939 and 1940, and for the Boston Braves in 1942. He entered the Hall of Fame in 1975. Averill died in 1983.

JOHN SPELLMAN

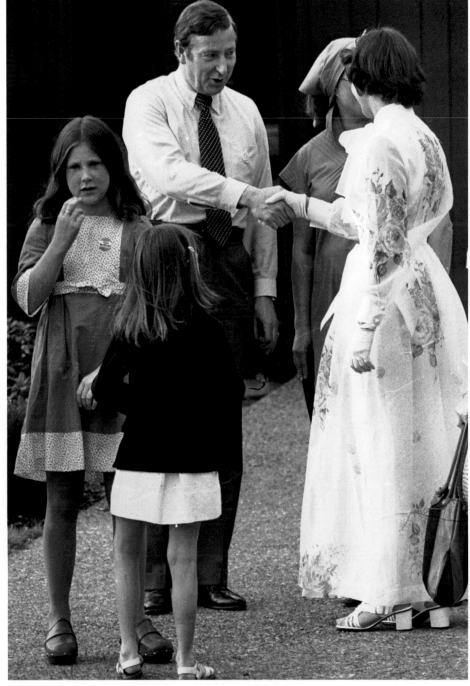

A Seattle native, Republican JOHN SPELLMAN was King County executive when this photo was taken in Seattle in 1976. As county executive, he was instrumental in construction of the Seattle Kingdome. Spellman served in that position from 1969 until 1981, when he was elected governor of Washington state, serving one term. He failed to win re-election in large part due to a budget crisis that led to sharp spending cuts and increased taxes.

It was a youthful CHARLES ROYER, 38, who became mayor of Seattle in 1978, a year before this photo was taken. A former television journalist in Portland and Seattle, the Medford, Oregon native served three four-year terms as Seattle mayor, the longest tenure in the city's history, guiding the city through a period of rapid growth. Royer won several national awards during his terms as mayor.

U.S. Rep. JOEL PRITCHARD, a Republican, served Washington state in Congress from 1973 until 1985 and later as lieutenant governor from 1989 until 1997.

This life-size gold and lapis mask of Egypt's "BOY KING" was on display at the "Treasures of King Tutankhamen" exhibit at the Seattle Center in 1978. Some 1.3 million people viewed the exhibit.

At 8:32 a.m. on the morning of May 18, 1980, Mount St. Helens in southwestern Washington erupted, sending smoke and plumes of ash skyward to 60,000 feet. Fifty-seven people died. The volcano continued to erupt off and on until 1986 before quietly oozing out pasty lava and slowly building a new dome in its horseshoe-shaped crater.

An "explosion" of a different sort took place a few years later. The Washington Public Power Supply System was created in 1957 to work with the state's municipal utilities and Public Utility Districts to build a series of nuclear power plants around the state. It's acronym, WPPSS, evolved into "Whoops." In 1983, it lived up to its nickname: it defaulted on $2.25 billion in bonds when construction of two of its power plants were halted. It was the largest municipal bond default in U.S. history.

The '80s saw the rise of "grunge rock," a music unique to Seattle. The early grunge movement propelled *Nirvana* and *Pearl Jam* to commercial success.

The decade also saw the start of a success story that had a major impact not only on the region, but on the world. In 1975, Paul Allen and Bill Gates co-founded a company called Micro-Soft in Albuquerque, New Mexico. In 1979, they moved the company to Bellevue, across Lake Washington from Seattle, their hometown. In the mid-1980s, the company, by then known as Microsoft, moved again, this time to nearby Redmond, where it began developing a campus larger than many colleges.

1980s

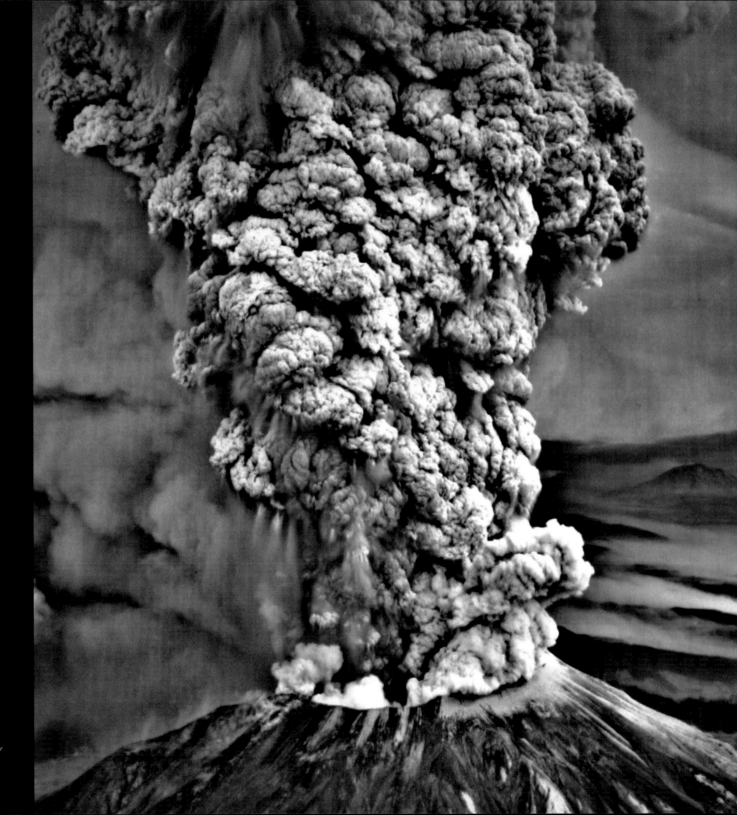

Mount St. Helens
blows its top.

May 18, 1980

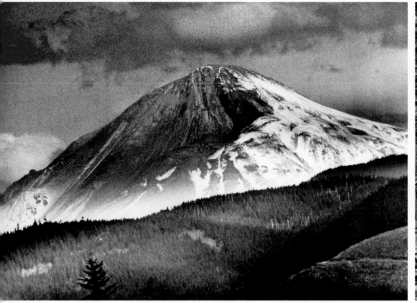

One of the last views of the mountain when it was whole.

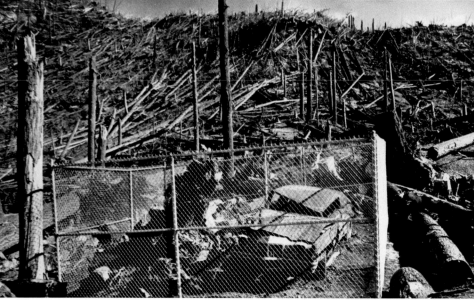

Nearly 150 square miles of timber were flattened by force of the

On this spring day that will be remembered forever in the Pacific Northwest, an earthquake triggered a massive landslide that sent much of the north face of Mount St. Helens plunging down the mountain. The avalanche relieved the pressure inside the volcano and a lateral blast of hot gases, rocks and mud swept over the ridges below the summit, leveling nearly 150 square miles of forest and foothills and turning the Toutle River into a mud flow.

Then, the summit exploded, sending a plume of ash, steam and smoke seven miles into the air and leaving a mile-wide horseshoe-shaped crater. The eruption continued for nine hours.

Fifty-seven people are known to have died in the eruption but some believe the true death toll was considerably higher.

PERSPECTIVE

The dramatic photo at the start of this section, published with permission of the U.S. Geological Survey, is the only image in this book that isn't mine. After waiting for something to happen, I missed the eruption! This is what happened:

I spent two weeks in May, 1980 on assignment at Mount St. Helens after scientists said an eruption was imminent. Staying at a motel in nearby Longview, Washington, not far from the base of the mountain, I ventured beyond the roadblocks every day looking for good vantage points from which to take pictures. One of these

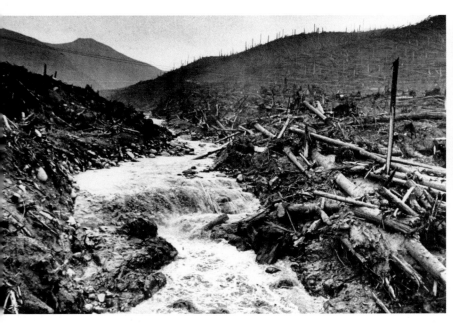

powerful eruption.

was a porch at the home of Harry Truman, the mountain man who died in the eruption.

My assignment was interrupted by a long-planned family vacation trip to Paris, France. We heard about the eruption while sitting in an apartment in Paris. Raleigh and I were shocked to discover that every single place from which I had taken pictures, including Harry Truman's porch, was destroyed.

It would have been sure death for me had I been on the mountain that day. But it wasn't my time.

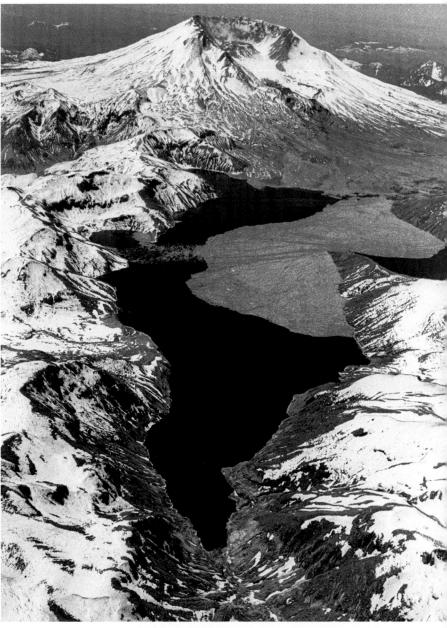

The once-beautiful Spirit Lake filled with debris from the blast.

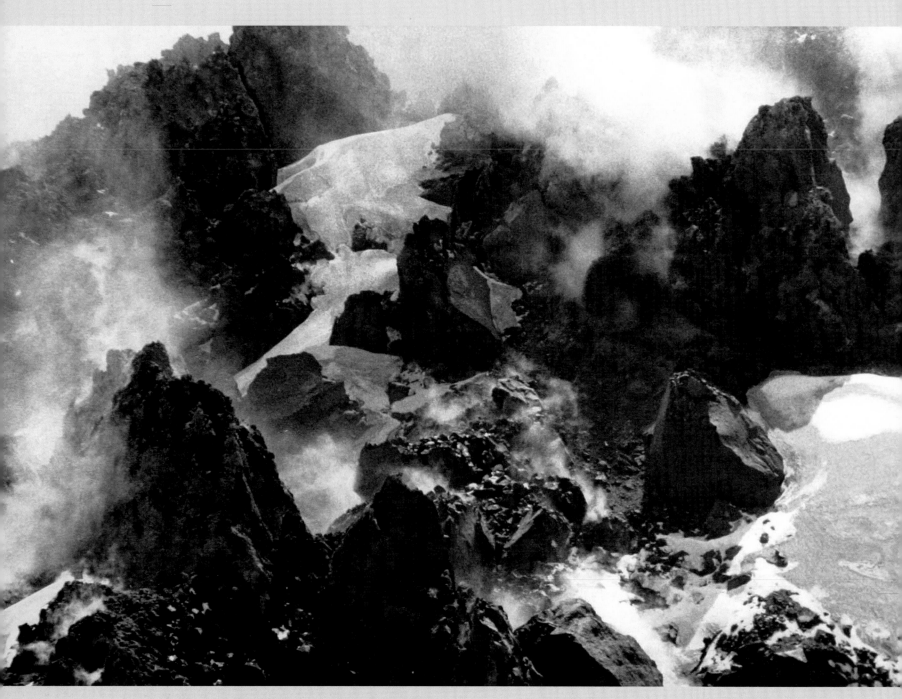

Snow covers the cap of Mount St. Helens in May, 1985 with Mount Rainier shining in the background. The volcano continued to erupt until 1986,

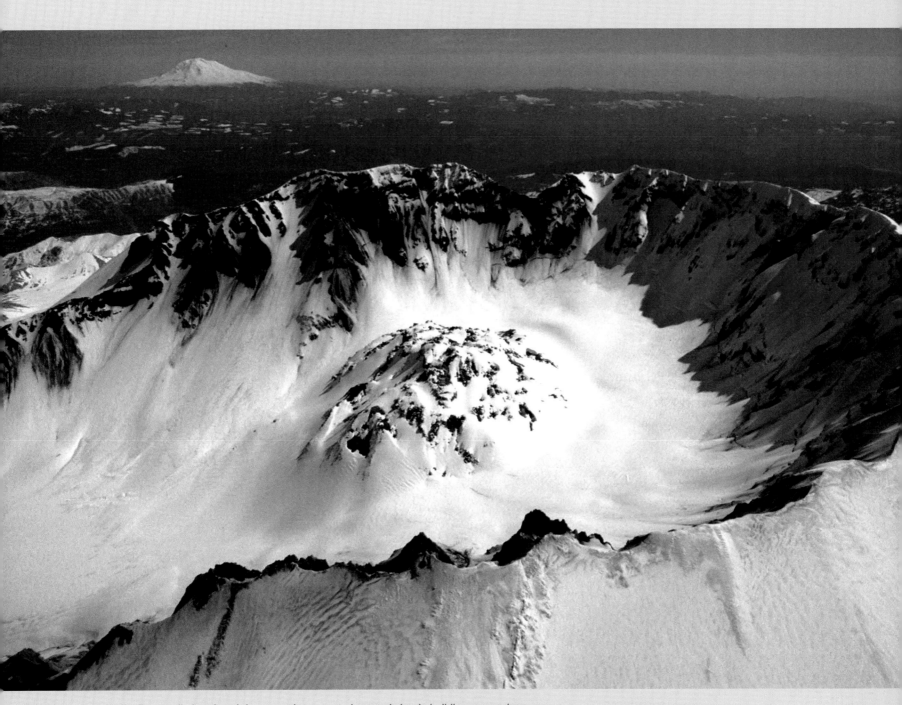

sometimes violently. Eventually it quieted down, oozing a pasty lava and slowly building a new dome.

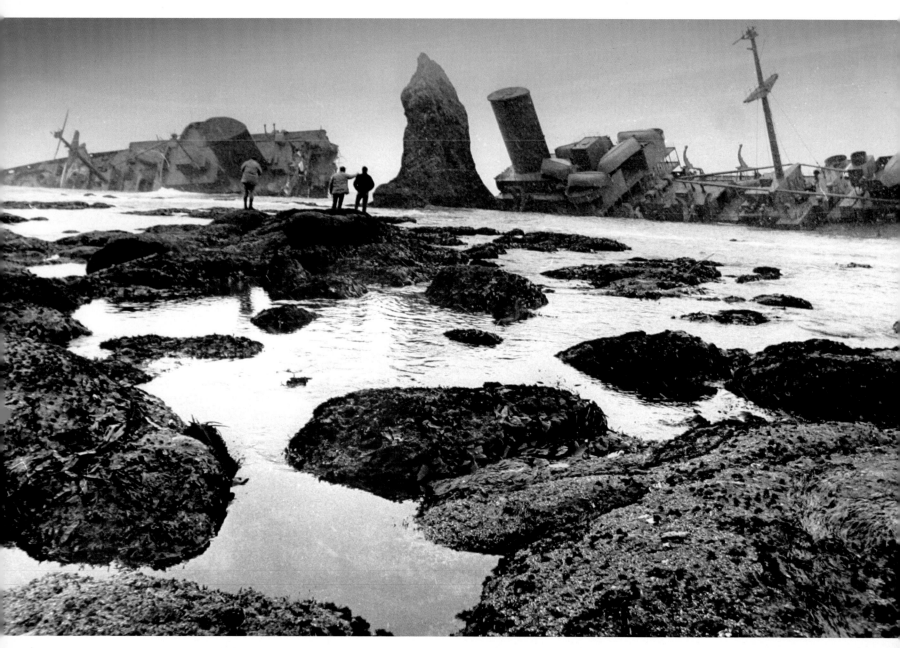

This ship, being towed to a scrap yard, ran aground in rough seas off the northwest tip of the Washington coast, hit a rock, and broke in half. The vessel became a tourist attraction, drawing many sight-seers on a mile-long hike to its final resting placing on the coast. This photo was taken in 1980.

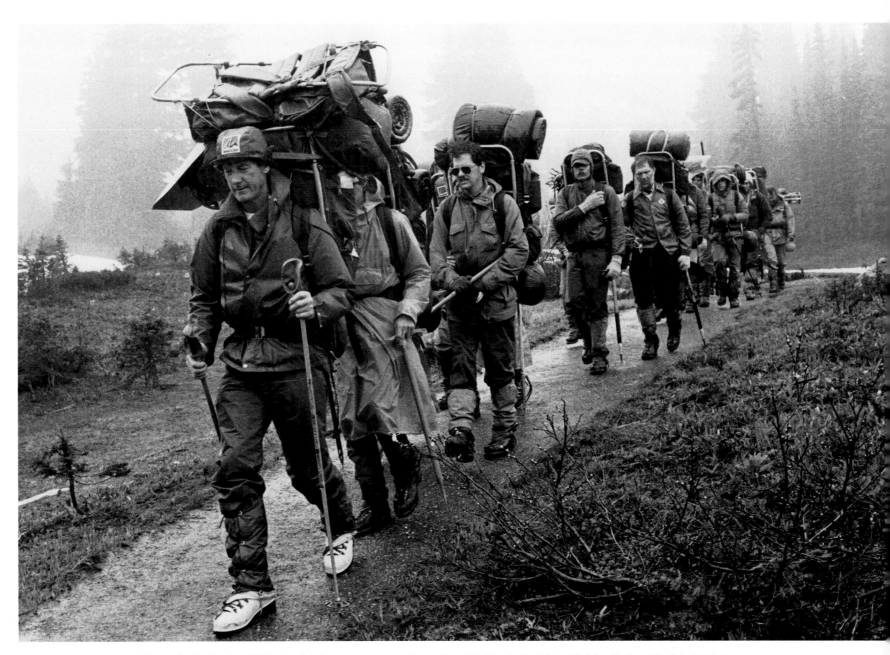

Mountain-climber Lou Whittaker leads a rescue team down Mount Rainier in the Mount Rainier National Park in 1980. He is the twin brother of Jim Whittaker, the first American to climb Mount Everest. Lou Whittaker climbed to the summit of Mount Rainier more than 250 times, many as operator of the company that guided climbers to the top of the famous peak.

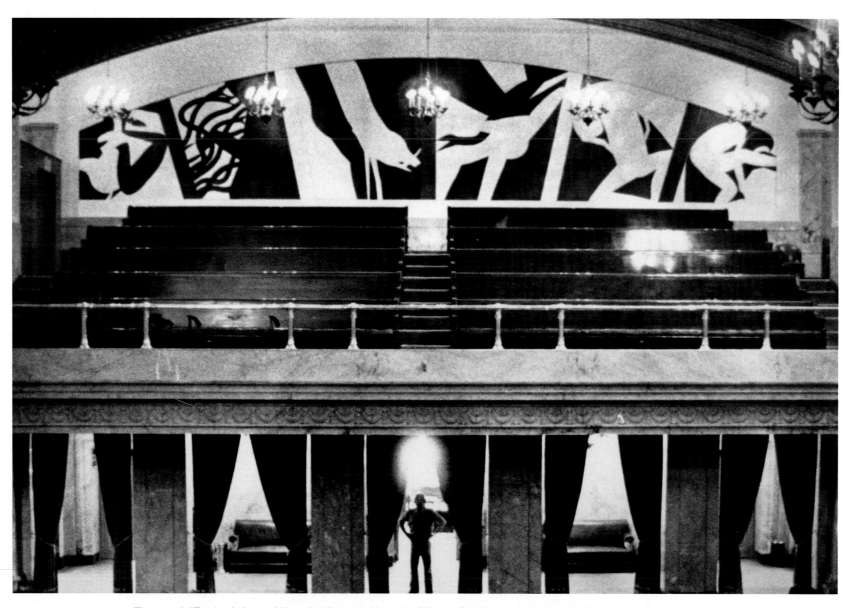

The mural, "Twelve Labors of Hercules," created by artist Michael Spafford in 1981 for the Washington House of Representatives chamber in Olympia, resulted in legislative censorship. The mural was covered with plywood after a state representative complained that the depiction of the death of the Amazon queen Hippolyta glorified rape. The mural later was displayed at Centralia College, and stayed there, despite grumbling by the unhappy artist who said the artwork was right only in the space for which it was created.

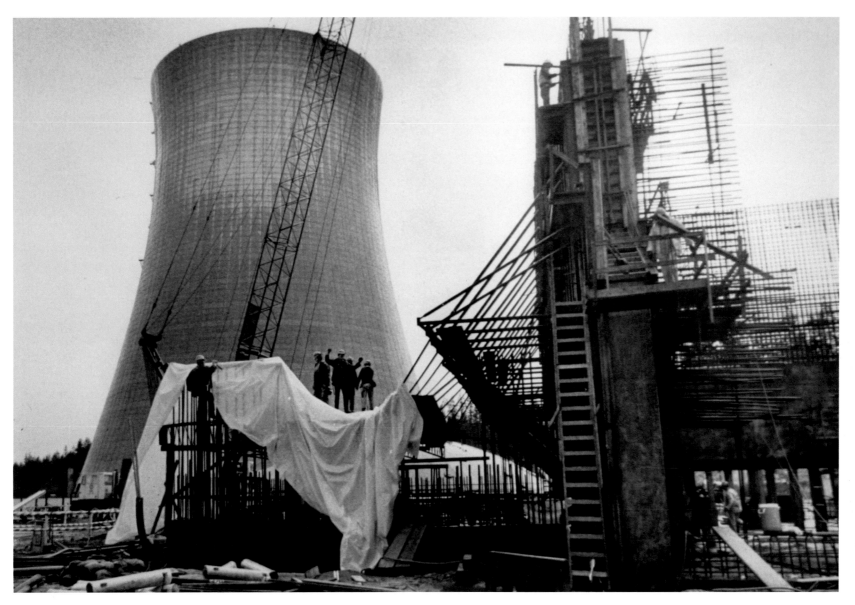

This shot of the cooling tower at Washington Public Power Supply Systems No. 3 in Satsop, Washington, was taken in 1983 after construction of the nuclear power plant was halted. Construction was started in 1977 but stopped six years later after a $961 million shortfall in the construction budget, leaving the plant 76 percent complete. Cost overruns and delays in building what was to be a network of five nuclear reactors led to a $2.25 billion bond default--the largest in U.S. history. The WPPSS fiasco came to be known as "whoops." The unfinished Satsop facility eventually became an office park.

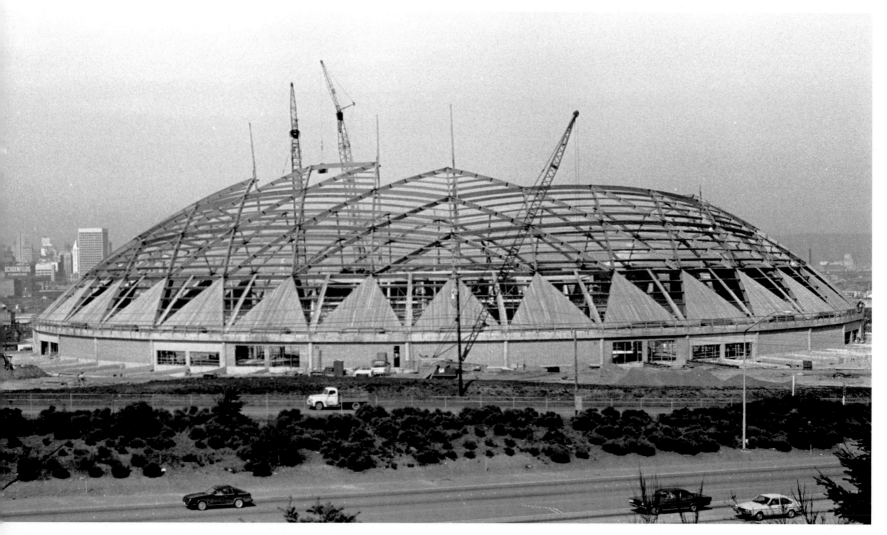

Construction is under way on the 152-foot-high Tacoma Dome in 1982. It was opened in April, 1983, and remains one of the largest wooden domed structures in the world. The dome was built with 1.6 million board feet of lumber. Owned by the City of Tacoma, it serves as a regional center for sports, entertainment, and cultural events with a maximum seating capacity of 23,000. Sixty-five percent of the seating is moveable to accommodate a variety of events.

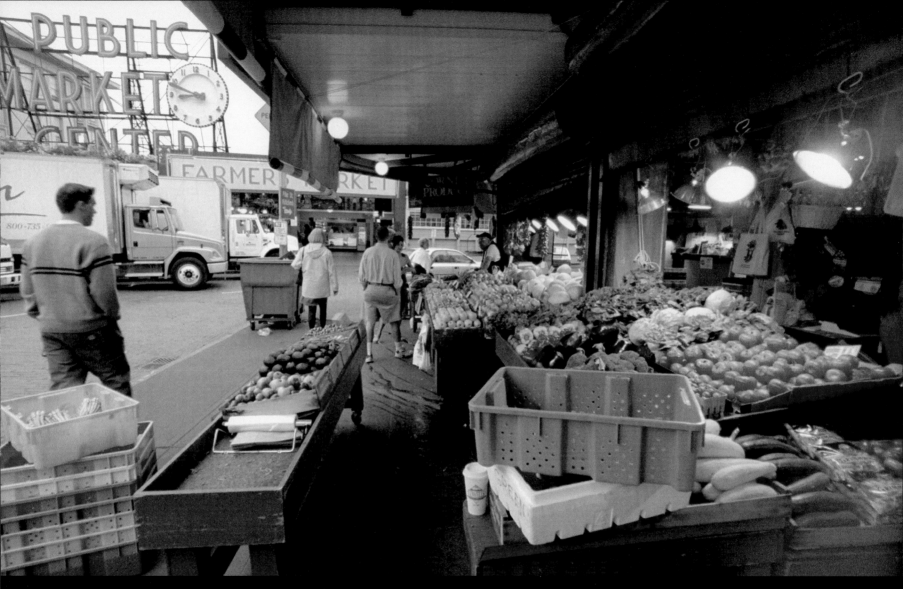

Pike Place Market is a famous Seattle landmark near the waterfront that draws tourists as well as Seattle residents. It is famous for its fish, fresh produce and flowers, and for its historic ambiance. The Market is often a backdrop for TV commercials including an icon showing fish mongers flinging salmon across the counter.

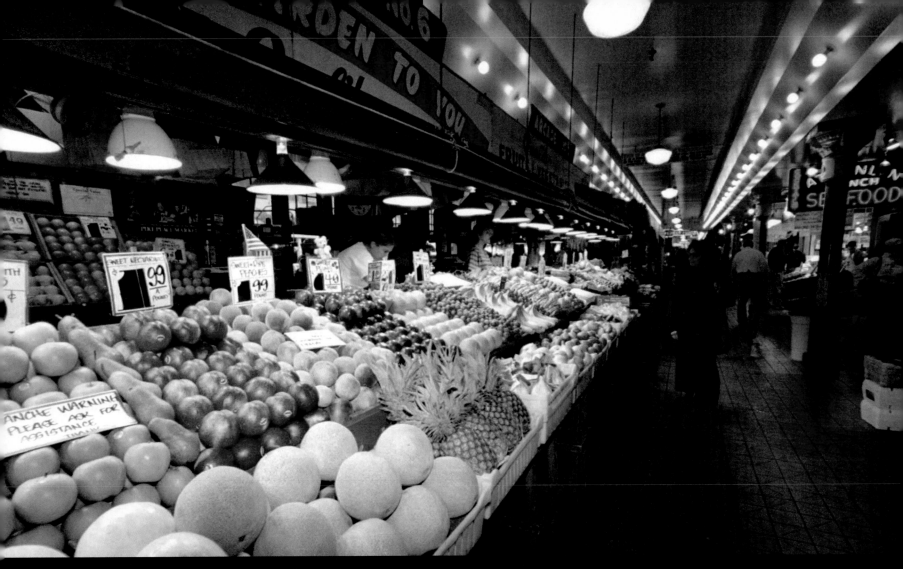

Fresh fruit and vegetables await visitors.

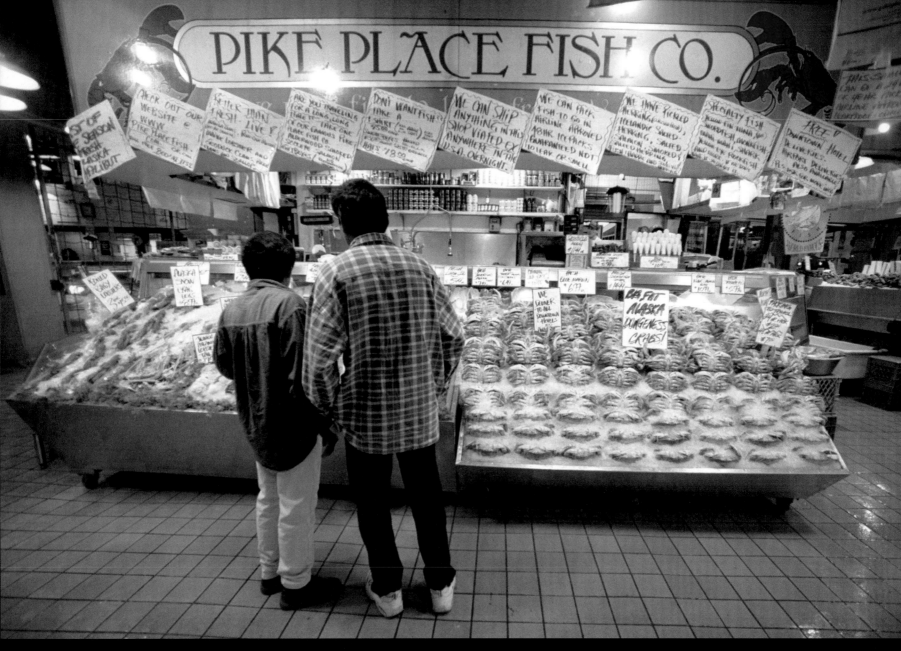

Fresh fish on display at the Pike Place Market

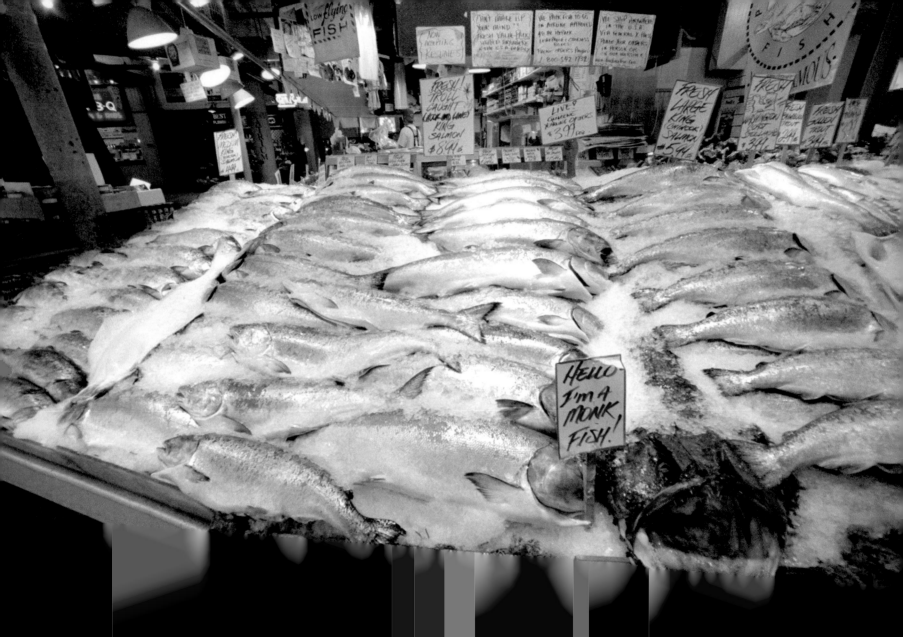

Madonna launches career in Seattle

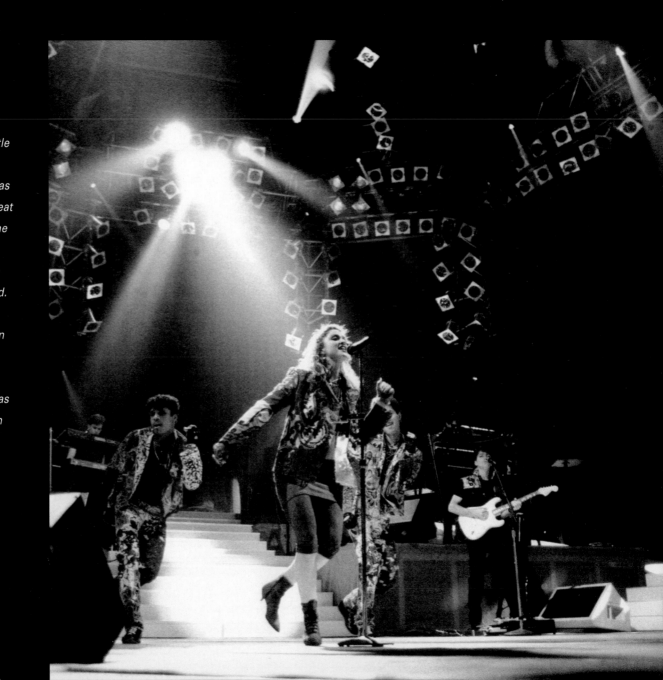

PERSPECTIVE

I got a phone call from somebody touting an entertainer coming to Seattle who, I was promised, would make for some very interesting pictures. She was described as a young singer with a great voice on her way to stardom. Her name was Madonna. This was her first tour. Oh, and she wears underwear outside her clothes. "She does what!?" I asked. Of course I went.

The pictures I shot of Madonna on the first stop of her Virgin Tour have been reproduced many times. I was told that one of my images was used as an enormous backdrop on stage when Madonna was inducted into the Rock and Roll Hall of Fame in 2008.

Pop singer Madonna, who became known for her outrageous costumes, sings in Seattle at her first-ever public concert at the start of her Virgin Tour on April 10, 1985. The Bay City, Michigan girl went on to sell more than 300 million records and CDs worldwide.

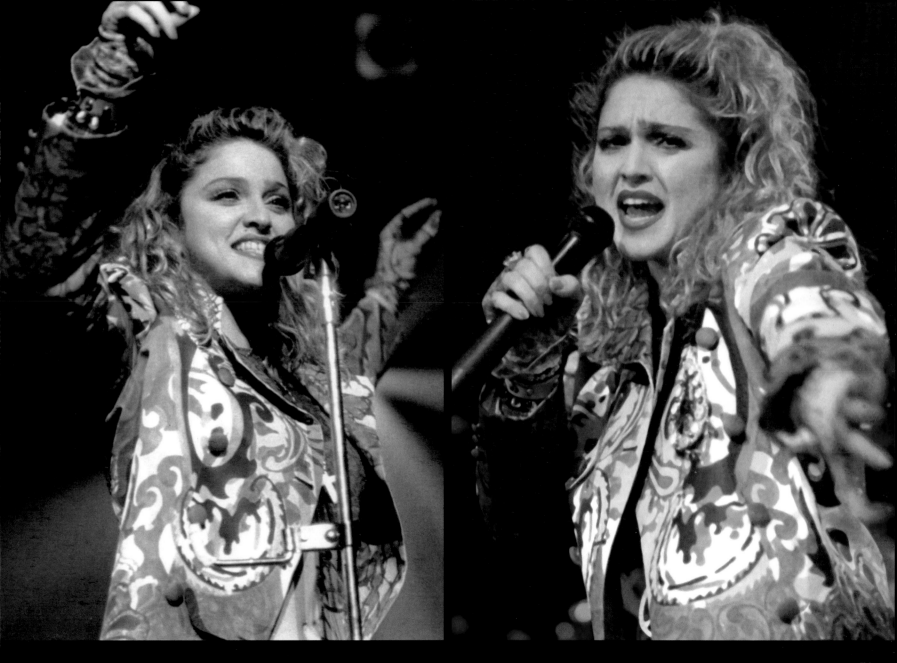

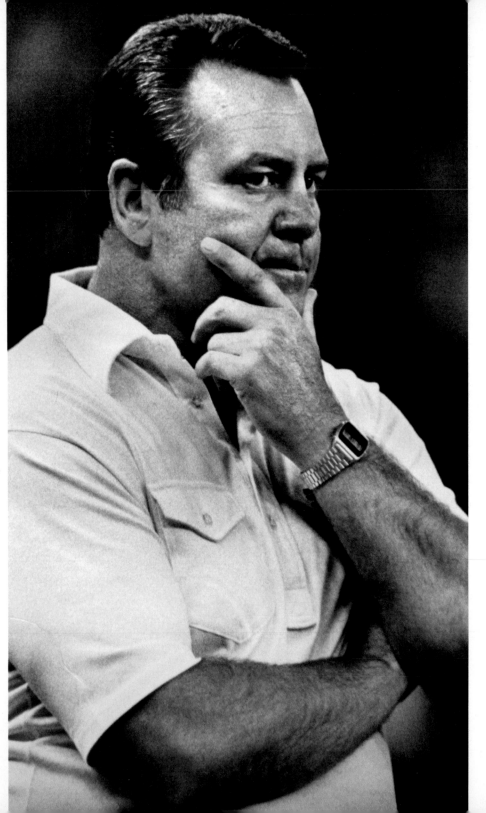

Fans loved and hated the Seattle Seahawks

Seattle Seahawks coach JACK PATERA watches practice prior to the opening of the 1980 National Football League season. Patera was hired in January, 1976 as the first head coach of the expansion team. Known for developing a risky pitch-and-catch offense with quarterback Jim Zorn and receiver Steve Largent, Patera coached the 'Hawks to 9-7 records in 1978 and 1979. He was named NFL Coach of the Year in 1978, but was fired in 1982 after losing the first two games that season following losing seasons in 1980 and 1981.

Fans loved and hated the Seattle Seahawks

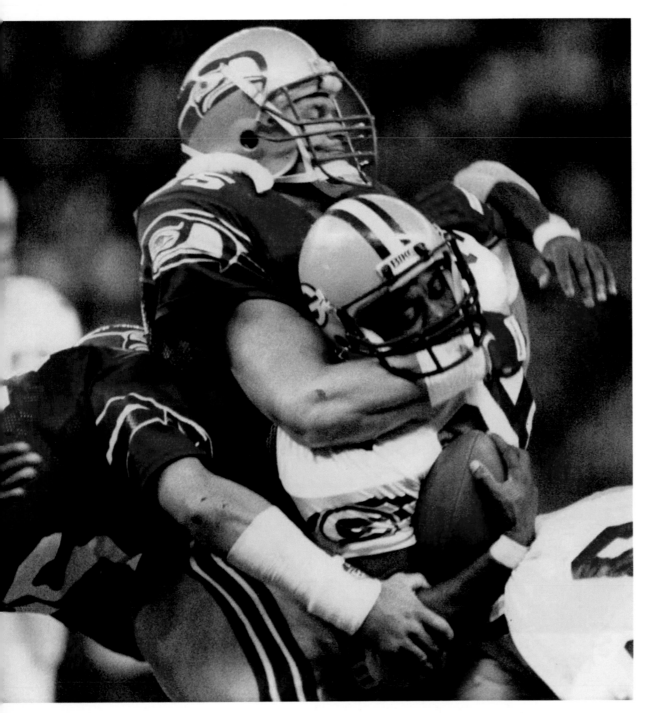

BRIAN BOSWORTH, an All-America linebacker at the University of Oklahoma, makes a tackle against the Green Bay Packers in 1987, his first season with the Seattle Seahawks. He was drafted by the Seahawks in the National Football League's supplemental draft that year and signed what was then the biggest rookie contract ever in the NFL--$11 million for ten years. He lasted only two seasons and part of a third, retiring in 1989 after two games due to a serious shoulder injury suffered the year before.

Seattle Seahawk STEVE LARGENT catches a pass for nine yards against the visiting San Francisco 49ers on September 26, 1988 to set a National Football League record of 156 consecutive game catches. He played thirteen seasons for the Seahawks and was inducted into the NFL Hall of Fame. After retiring from football, Largent served in the U.S. House of Representatives from his home state of Oklahoma between 1994 and 2002 and ran unsuccessfully for governor of Oklahoma 2002.

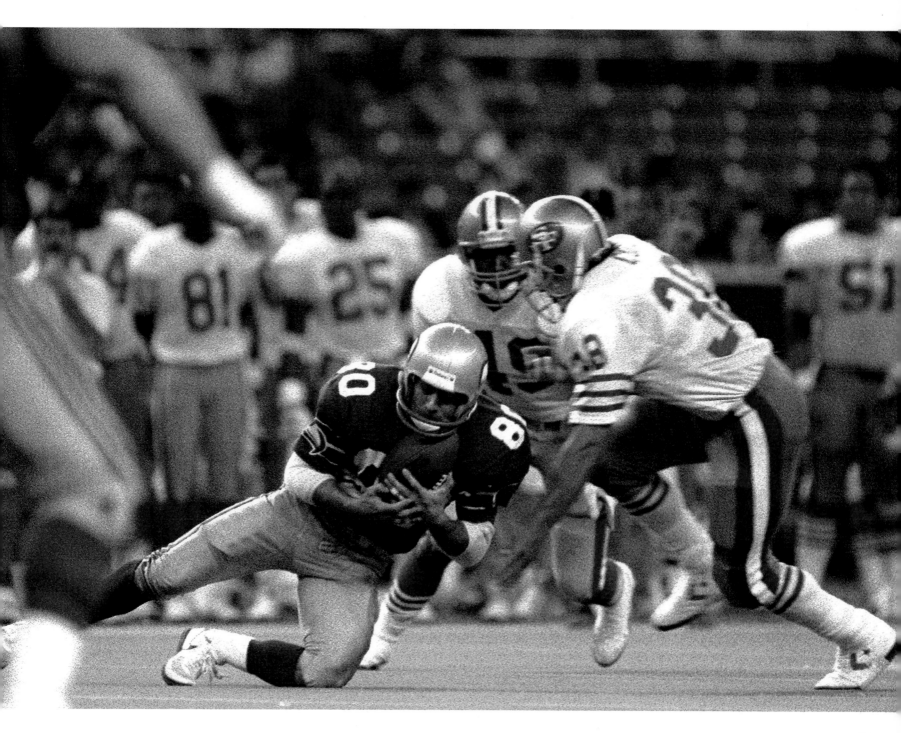

Faces in the crowd

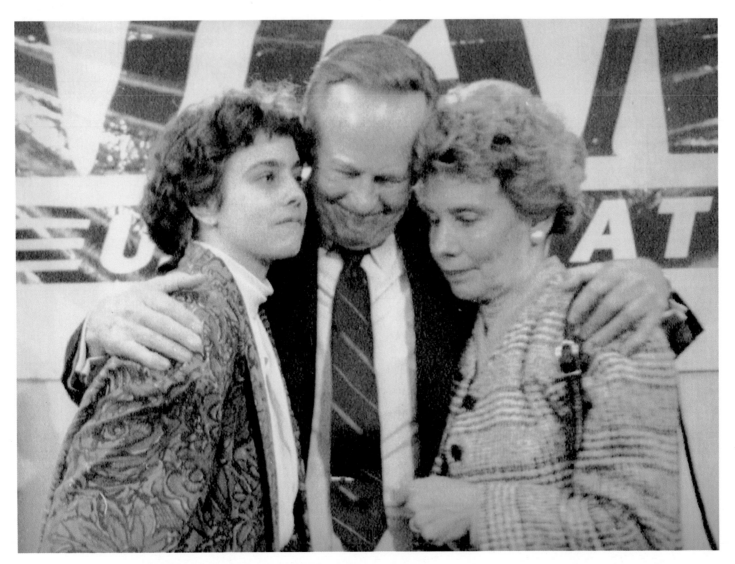

U.S. SEN. BROCK ADAMS, a Washington Democrat, announces at a press conference that he will not seek re-election in 1992 after reports appeared in the *Seattle Times* based on statements by eight women alleging various acts of sexual misconduct by Adams. Adams served in the U.S. House of Representatives from 1965 until 1977, when he became secretary of transportation in the Carter Administration. He was elected to the U.S. Senate in 1986, defeating incumbent Slade Gorton.

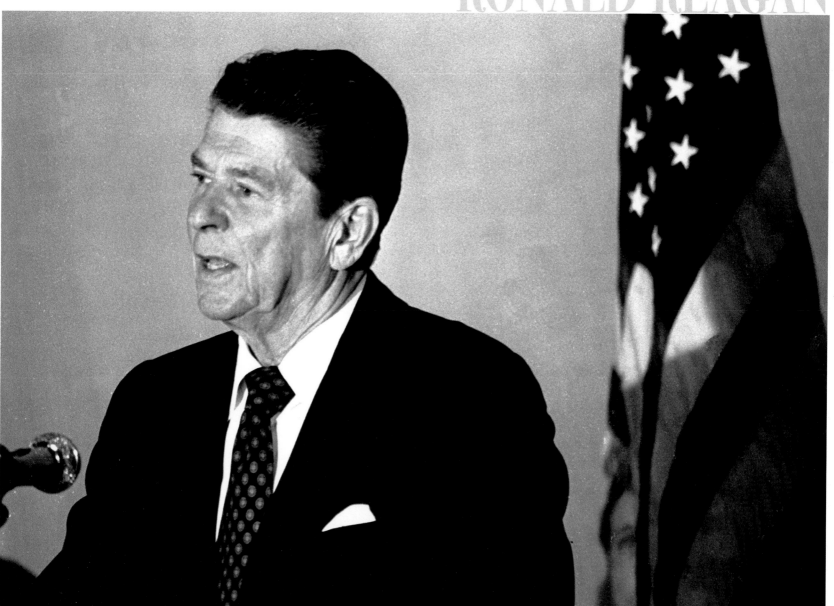

RONALD REAGAN speaks at a June, 1980 campaign rally in Seattle during his successful run for the presidency. Reagan won Washington state in 1980 and again in 1984, but no Republican presidential candidate has won the state since then.

Seattle Mariners pitcher GAYLORD PERRY, shown during an interview in 1982, played for the Mariners only a part of two seasons, but made his mark in the record books with them by winning his 300th game in Seattle on May 6, 1982. Often accused of throwing an illegal "spitter," Perry was kicked out of a game against Boston on August 23, 1982 – the first time he ever was ejected for doctoring the ball.

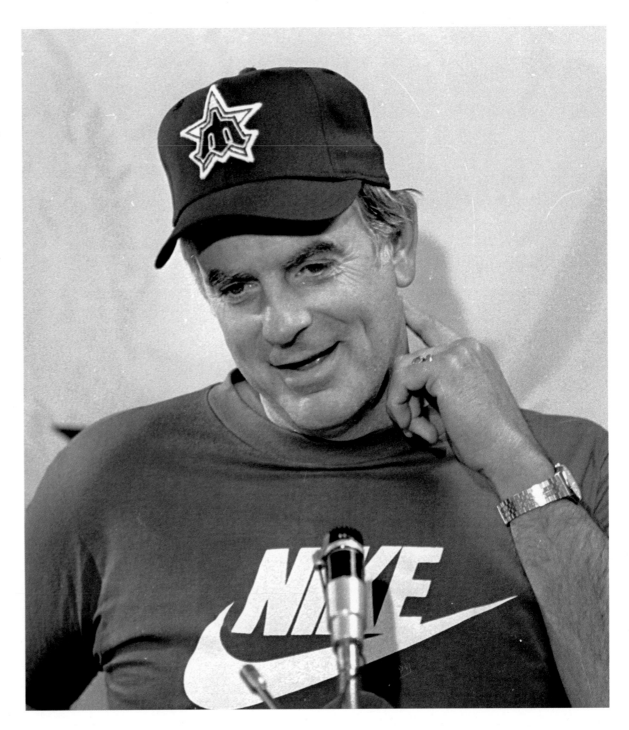

Clockwise from upper left: BOOTH GARDNER, an heir to the Weyerhaeuser timber fortune, was elected the nineteenth governor of Washington in 1986 and served two terms. Gardner, a Democrat, was Pierce County executive before his election as governor. He was known for his interest in soccer. In 1976, he owned the Tacoma Tides during its one year in the American Soccer League and two years later became co-owner of the Colorado Caribous in the North American Soccer League.

U.S. SEN. SLADE GORTON, a Washington Republican, answers questions at a press conference in Seattle in 1983. He was elected to the Senate in 1980, defeating incumbent and long-time Senator Warren G. Magnuson. Gorton served one term and then was defeated in 1986 by former Congressman Brock Adams. In 1988, he ran for and won the Senate seat being vacated by Dan Evans. Gorton was re-elected in 1994 but lost six years later to Democrat Maria Cantwell.

SAM SCHULMAN, original owner of the Seattle SuperSonics of the National Basketball Association, announced at a news conference in October, 1983 that he was selling the team to Barry Ackerley for $21 million. Schulman brought an NBA championship to Seattle in 1979, twelve years after the team's inception in 1967.

Speaking at a news conference in October, 1983, University of Washington basketball coach MARV HARSHMAN recalled his nearly forty years of college coaching at Pacific Lutheran, Washington State University, and the UW. While guiding the Washington program from 1971 to 1985, Harshman was named Pacific 8 Conference coach of the year in 1976 and Pac-10 coach of the year in 1982 and 1984. He coached the gold medal-winning U.S. team at the 1975 Pan American Games and was enshrined in the Naismith Memorial Basketball Hall of Fame in 1985.

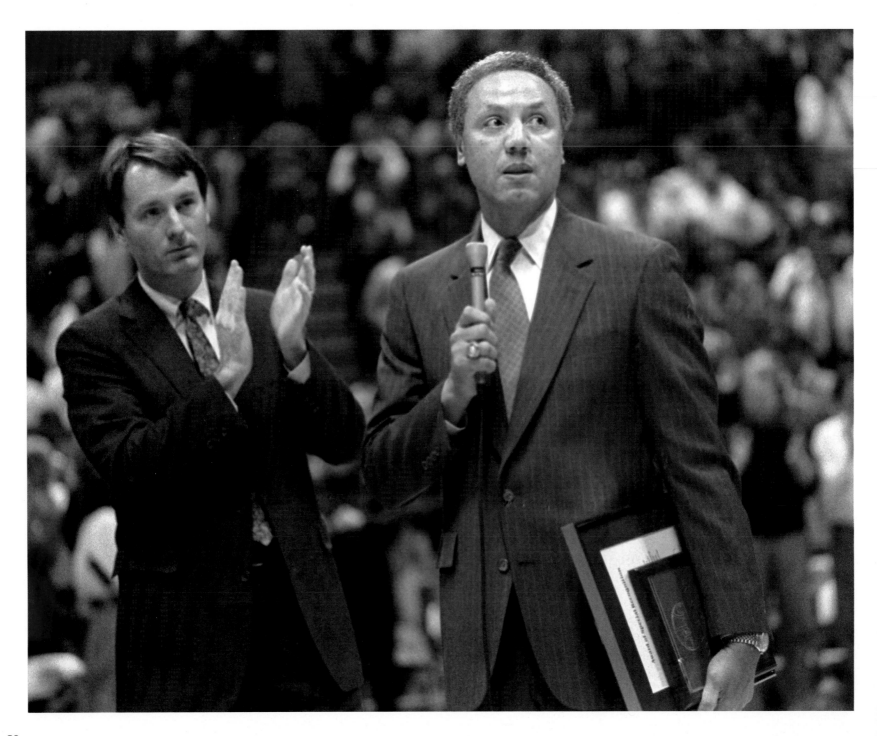

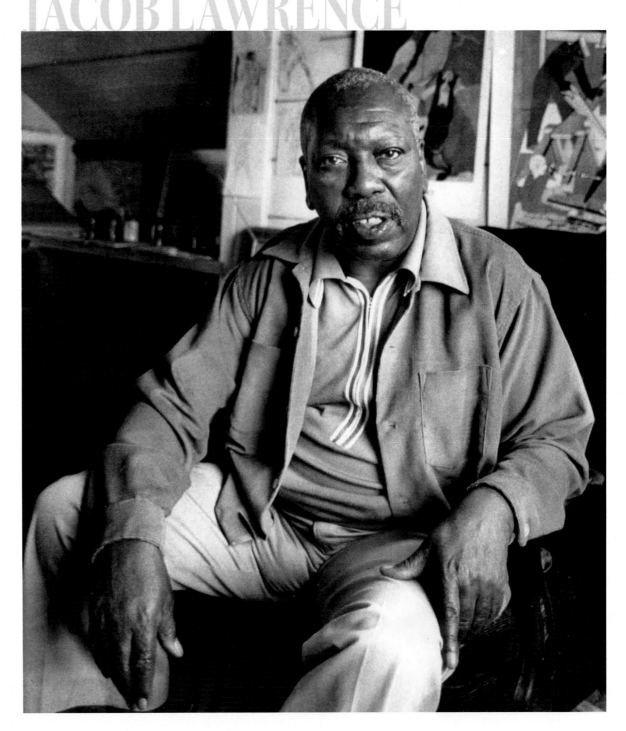

LENNY WILKENS, former Seattle SuperSonics player and coach, is applauded enthusiastically as Wilkens' uniform is retired in a March, 1987 ceremony attended by Sonics President Bob Whitsitt, left. As coach, Wilkens led his team to an NBA Championship in 1979. Ten years later, he was inducted into the Basketball Hall of Fame as a player, and in 1999 he was inducted a second time as coach.

Artist JACOB LAWRENCE poses in his Seattle studio in 1986. Lawrence is considered one of America's leading figurative artists for his works documenting black history. In 1937, at age twenty-one, Lawrence broken into the art world with his Toussaint L'overture series of forty-one paintings depicting the Haitian slave rebellion. In 1970, Lawrence was appointed professor in the School of Art at the University of Washington. He died in 2000 at age 83.

Protests and demonstrations once more dominated news coverage in the 1990s.

A conference of World Trade Organization ministers in Seattle made international headlines, more for its demonstrations, some violent, than for its working agenda. Protesters marched, held rallies, organized teach-ins, and clashed with police as they blocked streets and kept ministers from attending meetings.

Politics was in the news, too. The speaker of the U.S. House of Representatives, Tom Foley of Spokane, lost a re-election bid in 1994 after serving in the House for thirty years. Foley became the first sitting speaker of the U.S. House to lose a re-election campaign.

Boeing's rebound from the dark days of the 1970s perhaps was illustrated best when workers gathered to celebrate the success of the 757 passenger airliner. More than one thousand of the popular jets were sold.

In sports, Ken Griffey Jr. and Randy Johnson were the big names. Griffey was named the Most Valuable Player of the 1992 All-Star Game and American League MVP in 1997; Johnson recorded the first of 300-plus strikeout seasons in 1993 and won the American League Cy Young Award in 1995. By the end of the 1990s, both were gone. The decade also saw the flattening of a Seattle landmark, the old Kingdome. It was replaced by Safeco Field, where the Mariners began playing in 1999.

1990s: unwanted spotlight falls on seattle

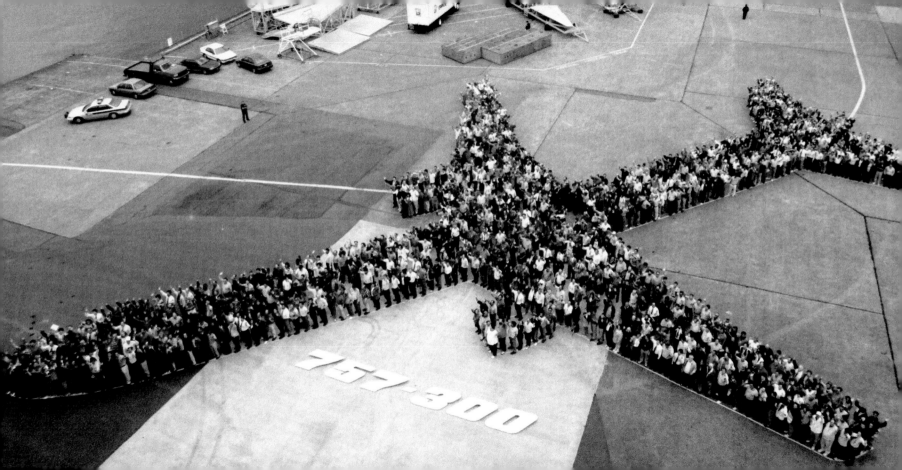

BILL CLINTON

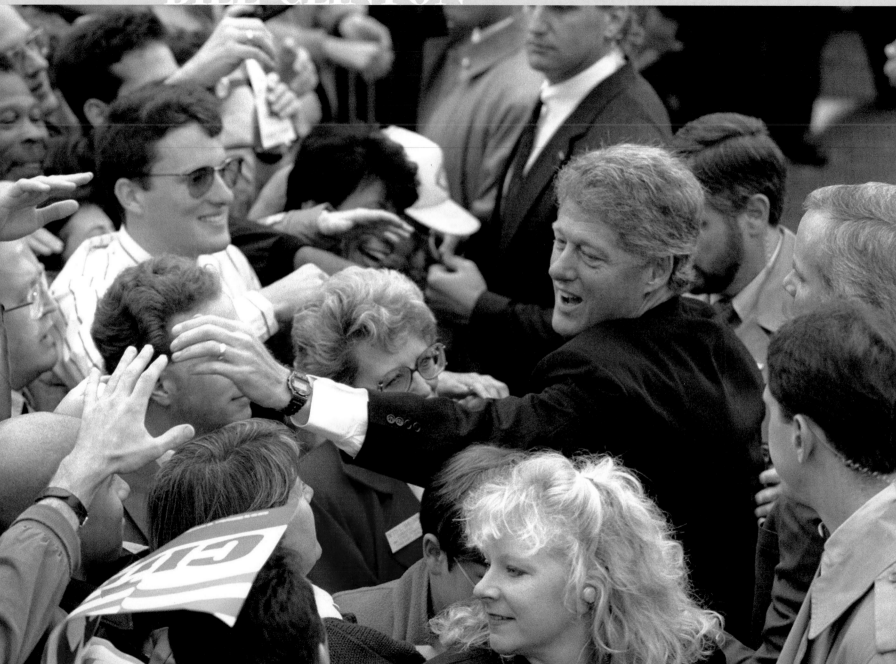

BILL CLINTON works the crowd during a campaign appearance in Seattle during his first run for the presidency.

Local boy makes good

PERSPECTIVE

I met Bill Gates early in his career. Microsoft had just moved to its campus in Redmond from a small building in Bellevue. Even then Gates knew he would become an important leader in the computer world. He wanted international awareness of his company and its products. Coverage in the local newspapers was not enough.

Bill or his secretary would call and tell me somebody from Intel, or Dell computers, or some other major player in the computer industry was coming by the office at 2 o'clock and would I care to stop by and take a few pictures? This happened over and over again for many years.

When AP in New York realized I had this access, I began to get special requests from throughout the world. So I would call Bill and tell him that, say, the London Times *wanted an exclusive photo; he'd look at his calendar and tell me he wasn't doing anything that afternoon, and why didn't I come out to his office and take some pictures?*

Later, as Gates became more important and Microsoft grew into a huge company, the security guards and public-relations people arrived. My access totally dropped off. The PR people would make sure I got invitations to major Microsoft events, but I didn't have the easy access to Bill anymore. It was gone, a victim of Microsoft's growth.

Microsoft's BILL GATES outside of his Redmond office in March, 1992. The Microsoft campus with its headquarters in Redmond, Washington is one of the Seattle area's major employers. The company was co-founded in 1975 by Gates and Paul Allen in Albuquerque, New Mexico, but moved to their home state a few years later.

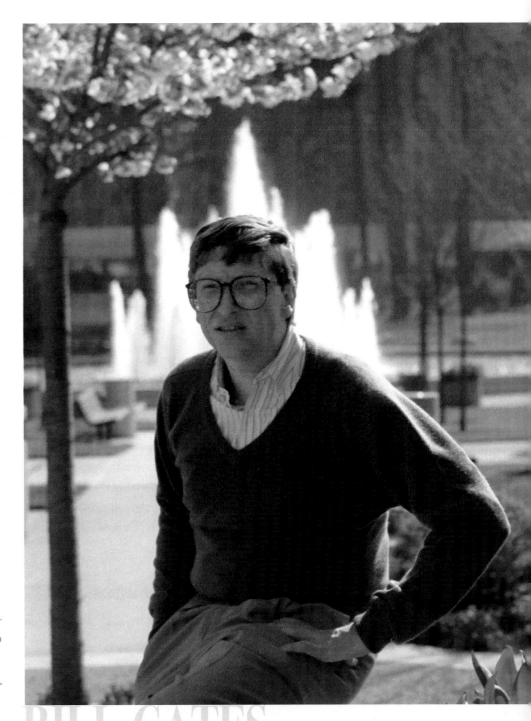

BILL GATES

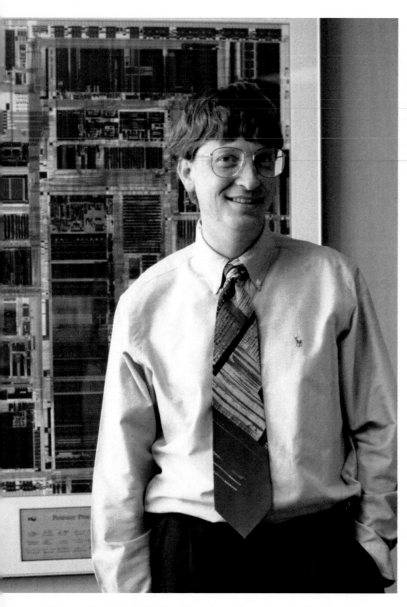

Microsoft's BILL GATES in front of a picture of an Intel chip

hanging in his Redmond office in May, 1993.

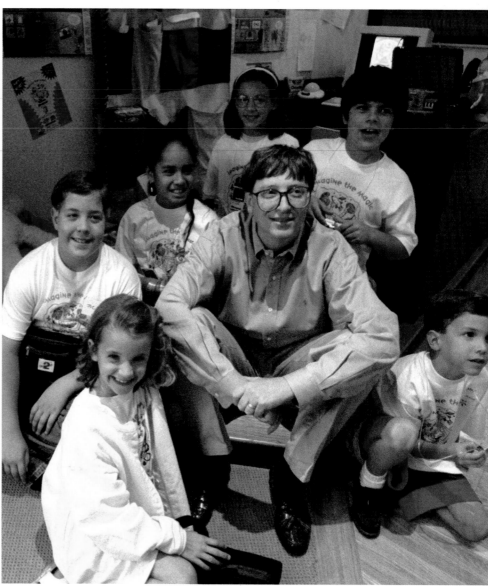

BILL GATES with children at Microsoft's Redmond headquarters

to promote the company's "Imagine The Magic" program

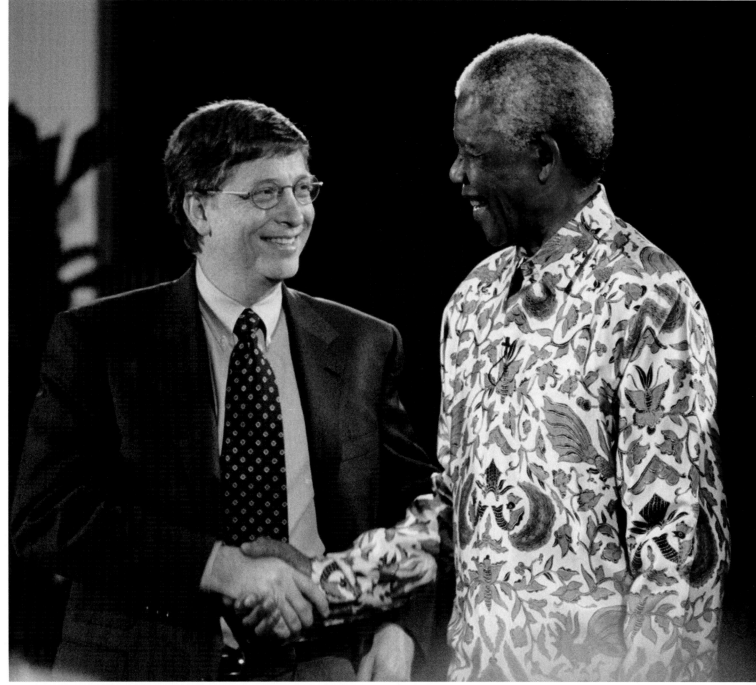

Microsoft CEO BILL GATES, left, meets in December, 1999 with NELSON MANDELA, then president of South Africa and winner of the 1993 Nobel Prize for peace. At a commencement address to Southern University's class of 2000 in Baton Rouge, Louisiana, Mandela drew laughs by comparing himself to Gates, saying, "I have thirty-nine grandchildren and six great-grandchildren. In this one thing, I'm richer than Bill Gates. It will take him a long time before he can reach my level."

87

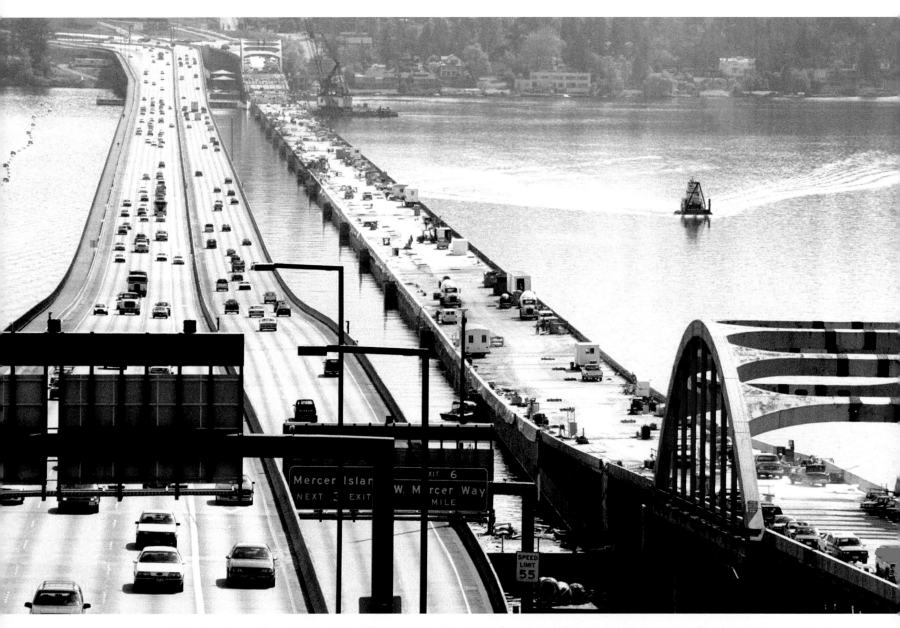

The last section of the Lake Washington floating bridge connecting Seattle and Mercer Island is put into position, completing repairs of the fifty-year-old structure. In November, 1990, the Interstate 90 bridge had broken apart and sections sunk during a week-long storm. An investigation revealed that hatchways into the bridge's concrete pontoons had been left open during a $35 million renovation, allowing water to enter. When the bridge was opened in 1940, the *Seattle Times* called it "the biggest thing afloat."

Photographed in
September, 1993,
"The Hammering
Man," a forty-
eight-foot-high,
22,000-pound steel
and aluminum
sculpture by
Jonathan Borofsky,
labors away
outside the Seattle
Art Museum.
Commissioned
for $400,000, the
artwork has a
motorized left arm
that hammers four
times a minute
to honor working
people, resting
at night and on
Labor Day.

Circus elephants
take a stroll
through downtown
Seattle in 1995.

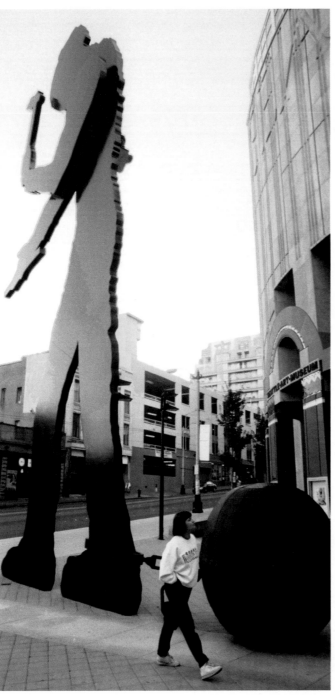

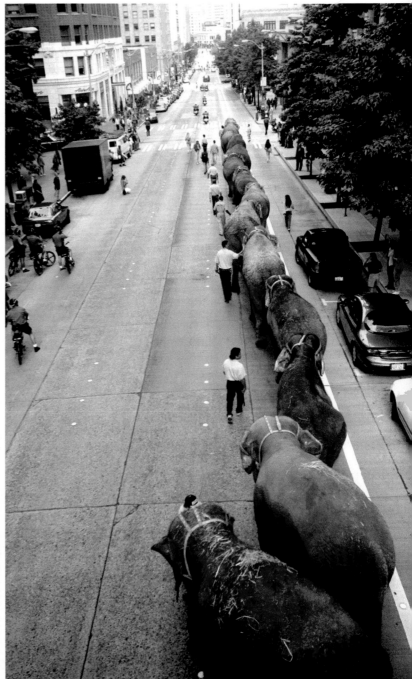

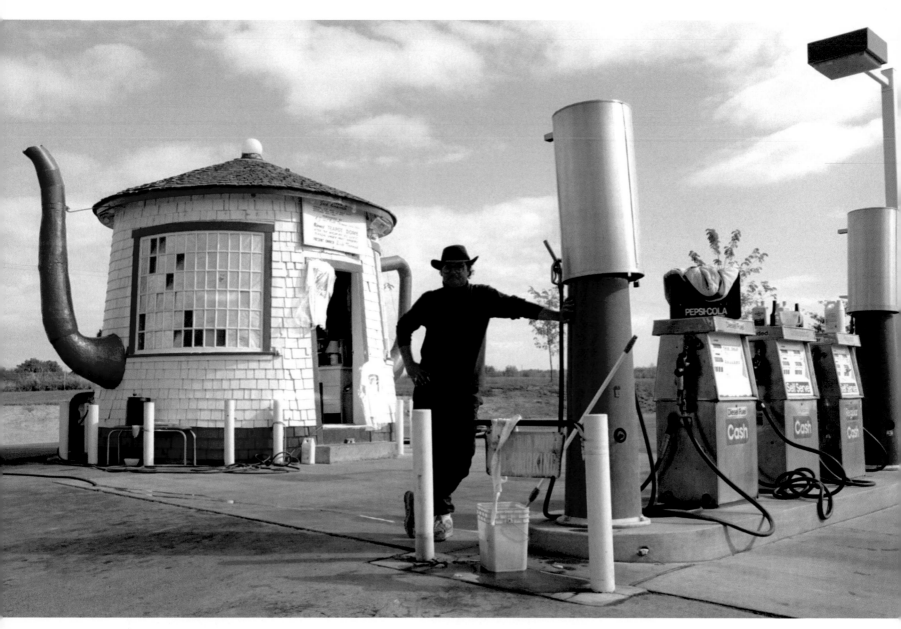

The "Teapot Dome," as it was known around Zillah, Washington, became an attraction in the early 1990s, as it was thought to be the oldest existing gas station in the United States. The owner, Lyn Dasso, is standing next to the pumps. The landmark had nothing to do with the Teapot Dome scandal over the leasing of naval oil reserves, although the U.S. Senate investigation of the leasing irregularities began in 1922, the same year the station was opened.

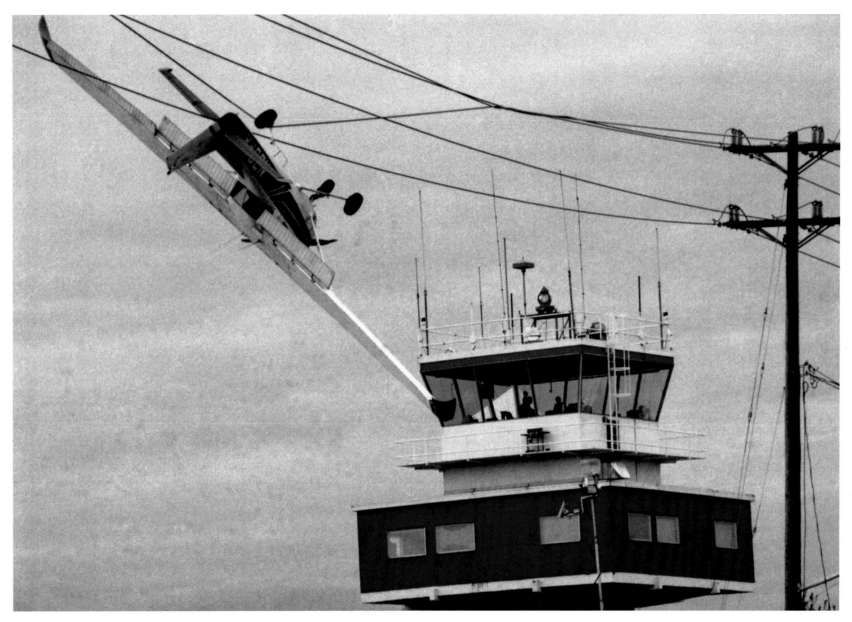

A small plane missed the runway and the control tower and landed precariously

in power lines at Boeing Field in Seattle on April 9, 1998. No one was hurt.

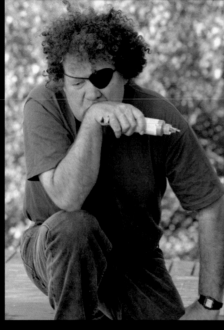

PERSPECTIVE

Dale Chihuly was becoming very big in glass art. I wanted to take a picture of him blowing glass, working in his studio. I called his office. He said, sure, come over and we'll go through my gallery. I spent a day there.

The artist would sit on the back porch of his studio on Lake Union in Seattle, sketching out his concept for a piece of art, then he would take it to his team of "blowers." This is how the art was created. His illustrations of what he visualized may be worth as much now as the glass art he first conceived on paper.

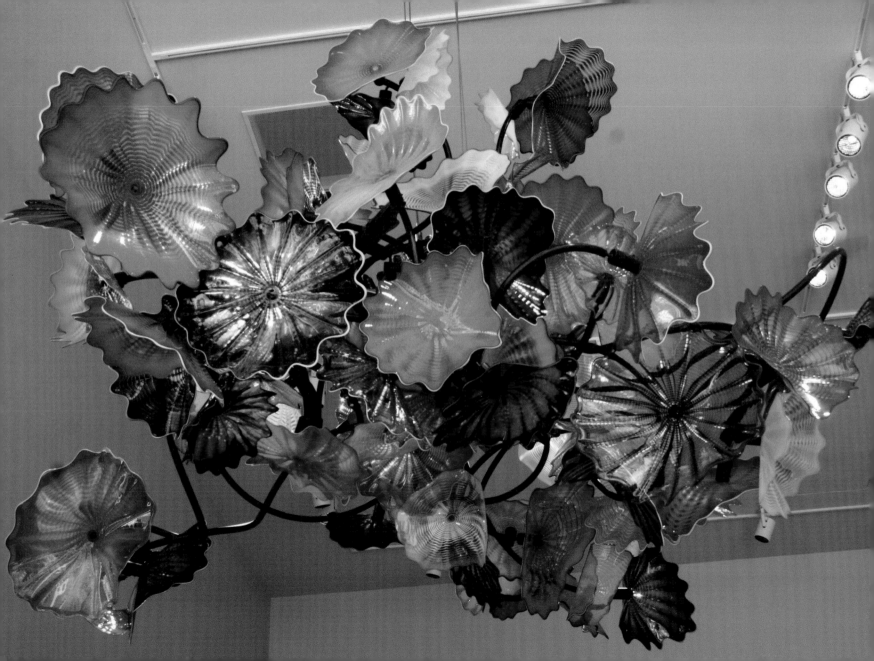

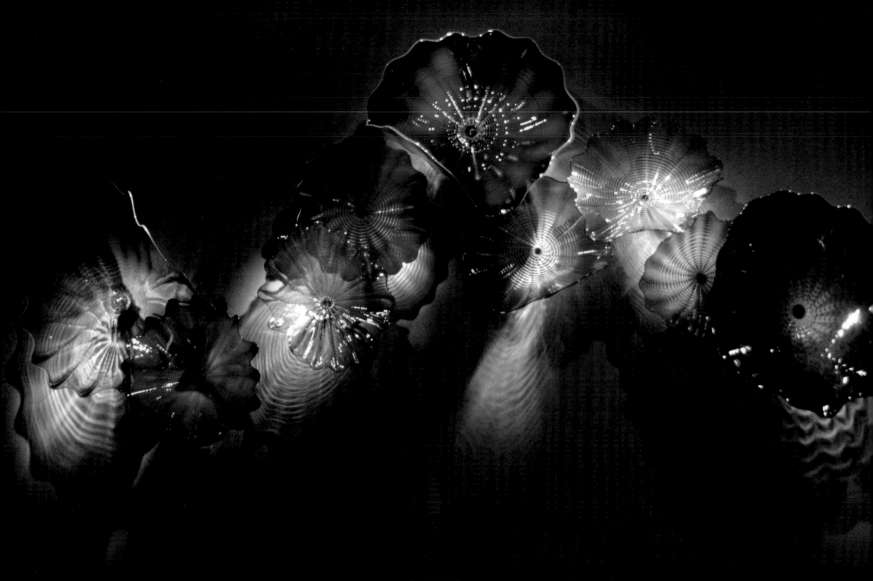

CHIHULY'S work graces many office buildings inside and out.

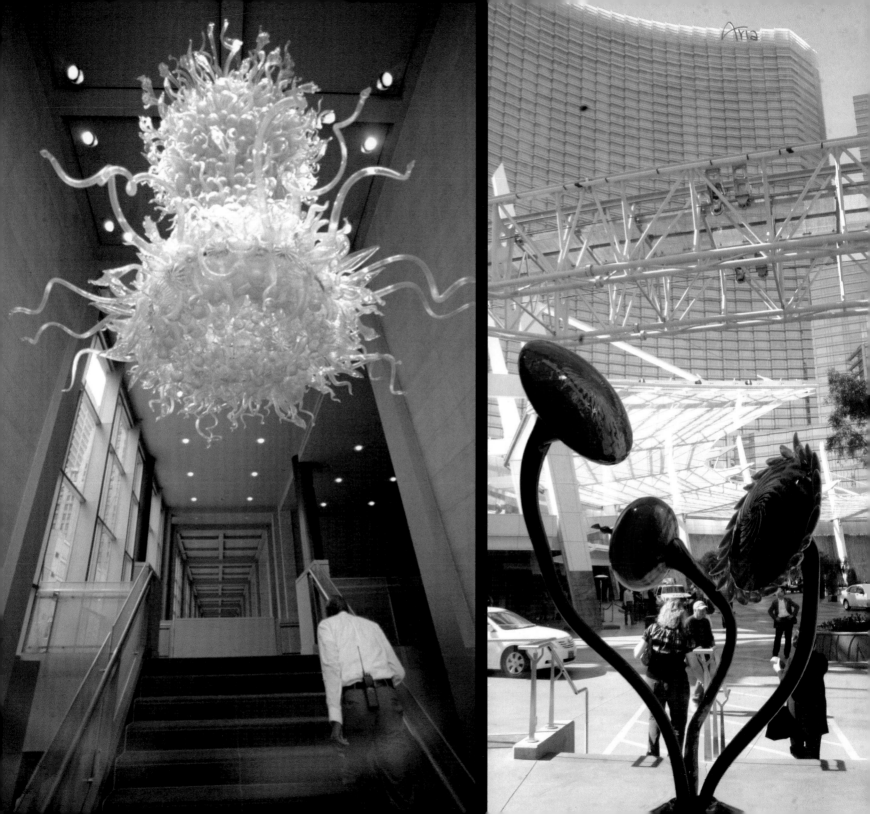

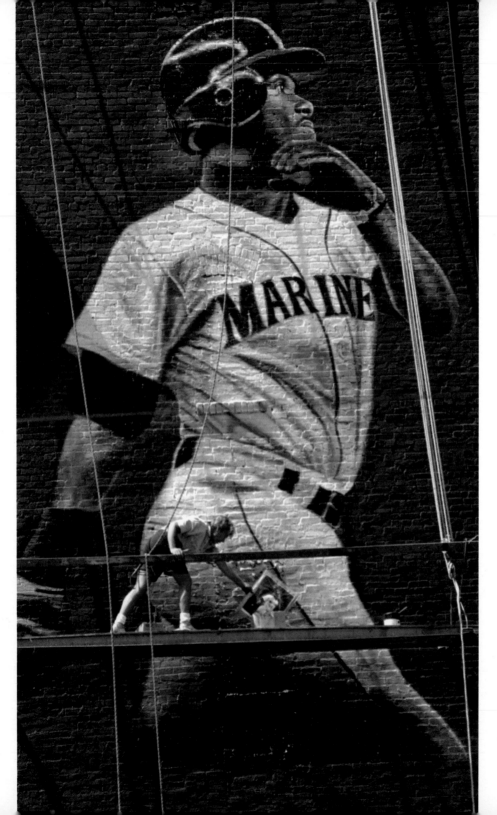

Ken Griffey Jr. and the Seattle Mariners

An artist works on a giant painting of Seattle Mariners superstar KEN GRIFFEY JR. on the side of a downtown Seattle building in June, 1993.

Seattle Mariners KEN GRIFFEY JR. scores in the third inning of a May 26, 1995 game against the visiting California Angels. Catcher Greg Myers looks at the loose ball as Griffey skids across the plate.

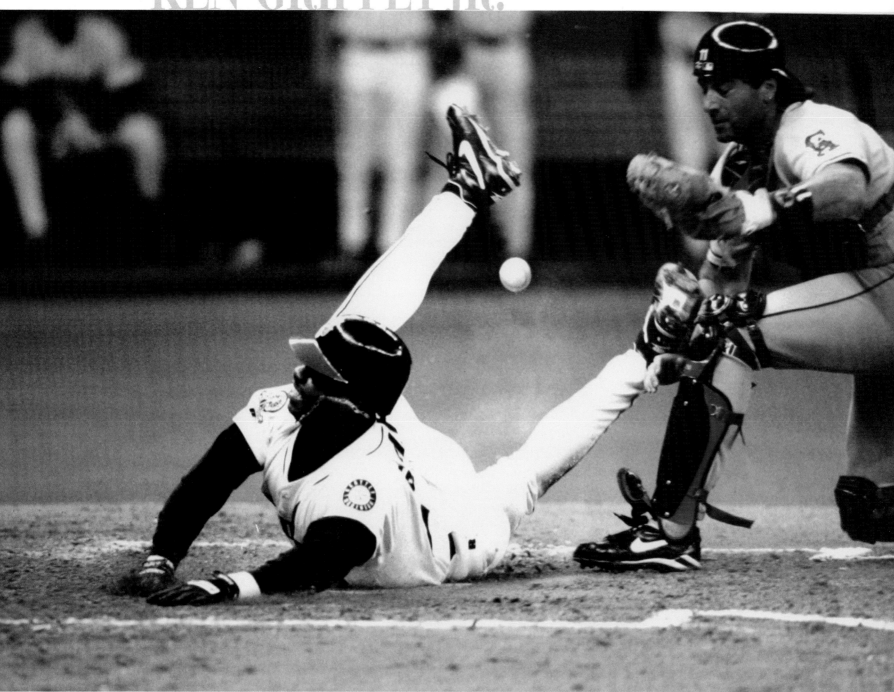

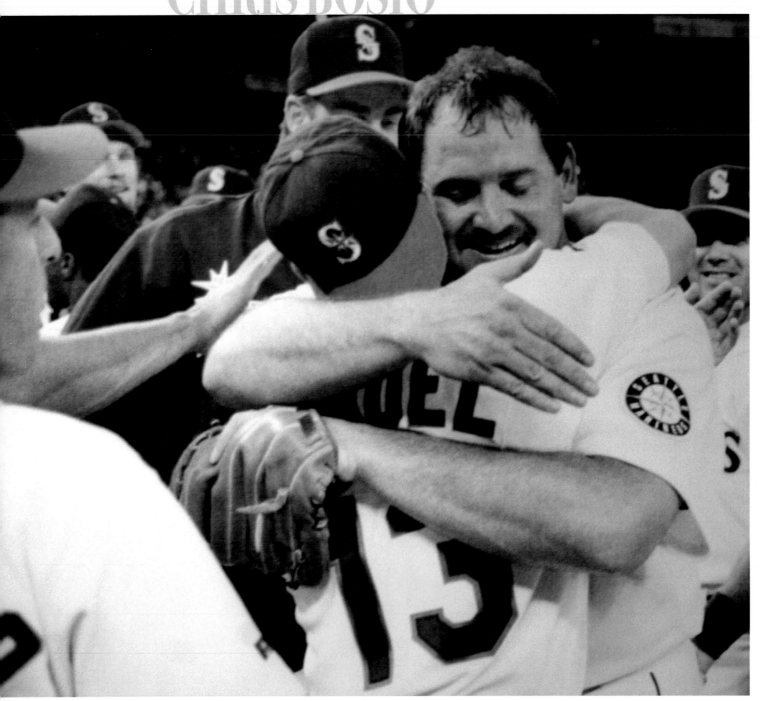

Seattle Mariners pitcher CHRIS BOSIO and teammates celebrate Bosio's no-hitter against the visiting Boston Red Sox on April 22, 1993. Bosio was only the second M's pitcher to throw a no-hitter. He played for the Mariners from 1993-1996 and began a career as a pitching coach after his retirement.

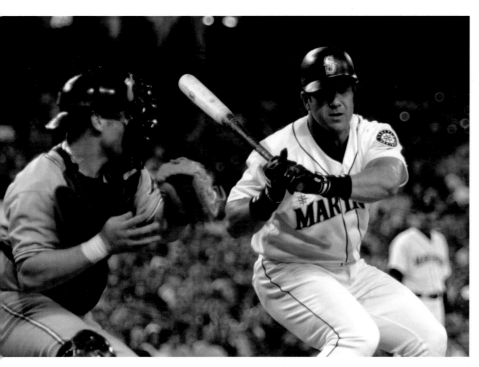

The Mariners' beloved designated hitter, EDGAR MARTINEZ looks for the ball and finds it in the glove of Tampa Bay's catcher Toby Hall at a game in Safeco Field.

Seattle Mariners pitcher RANDY JOHNSON celebrates after a strikeout in a game against the Baltimore Orioles in Seattle on October 1, 1996. The "Big Unit," as he was called, made a living on his hard slider and a fast ball that occasionally surpassed 100 miles per hour, recording the first of six 300-plus strikeout seasons in 1993 and leading the American League in strikeouts nine seasons. Johnson pitched one of his two no-hitters with the Mariners on June 2, 1990 against Detroit and won the Cy Young Award in 1995. He played ten seasons with the Mariners before being traded to Houston in 1998. During his twenty-two-year career, he played for six teams.

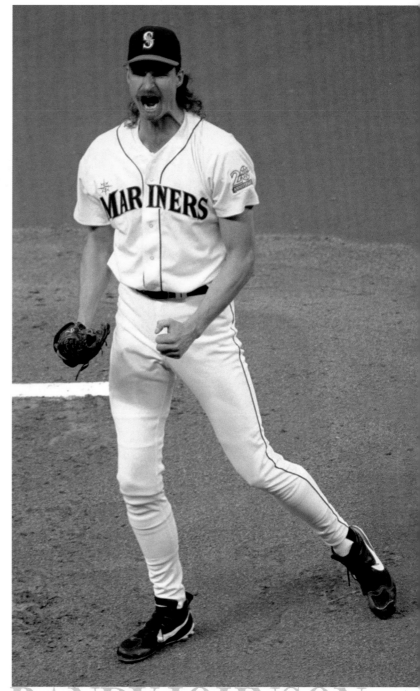

RANDY JOHNSON

Shown in an aerial shot in early June, 1999, Safeco Field was soon to replace the old Seattle Kingdome, seen in the background, as the new home of the Seattle Mariners. A site for the new ballpark was selected in 1996. A year later Ken Griffey Jr. helped break ground for Safeco Field. On July 15, 1999 a capacity crowd of 47,000 attended the inaugural game against the San Diego Padres. Naming rights were sold for $40 million to Safeco Insurance.

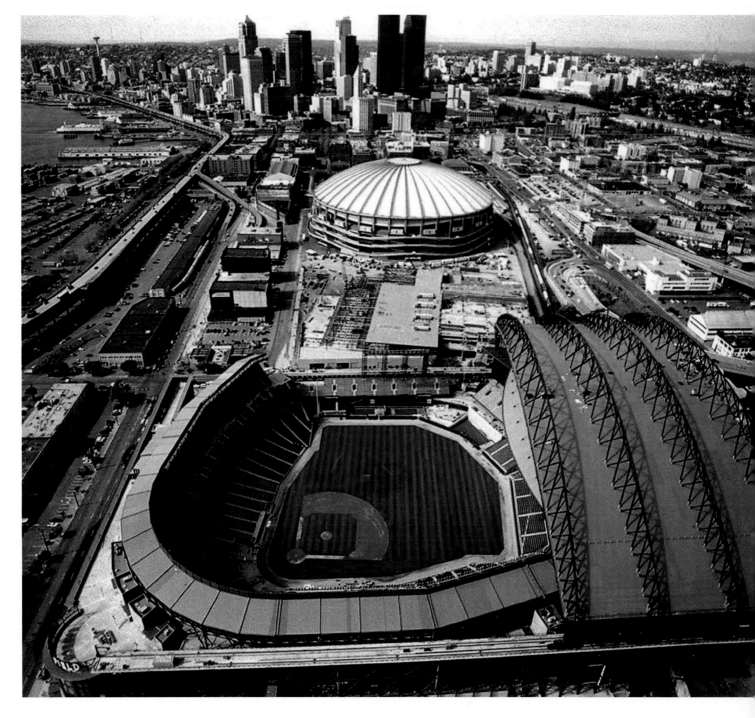

The historic Seattle Kingdome is demolished in a dramatic explosion on March 26, 2000 after nearly a quarter of a century as the home of Seattle's major league sports teams. It hosted the Seattle Mariners, Seahawks, Sounders, Sonics, NCAA Final Four tournament, rock concerts, motorcycle races, monster truck rallies, political events, corporate meetings, and religious crusades.

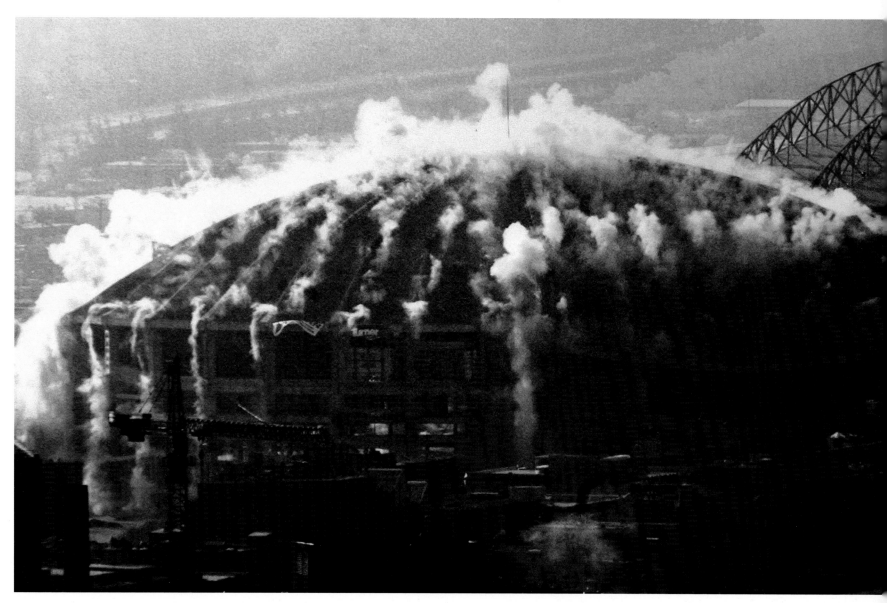

WTO protests in Seattle

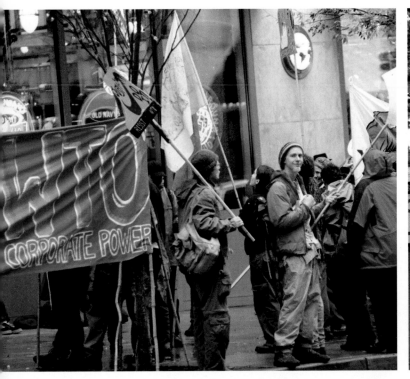

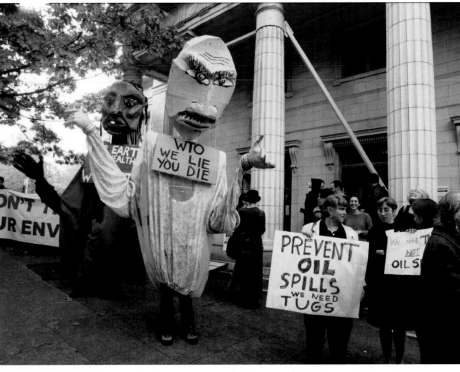

The WTO attracted many protesters with a variety of different grievances related to globalization.

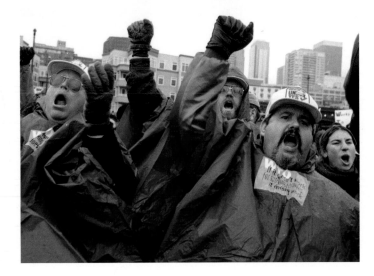

Police arrest demonstrators on November 29, 1999 during a World Trade Organization ministers meeting in Seattle that made international headlines for unexpected reasons. Protesters marched, held rallies, held teach-ins, and clashed with police, who used pepper spray, tear gas, stun grenades, and rubber bullets in an attempt to reopen blocked streets to usher WTO delegates through blockades. More than six hundred people were arrested over several days of protests.

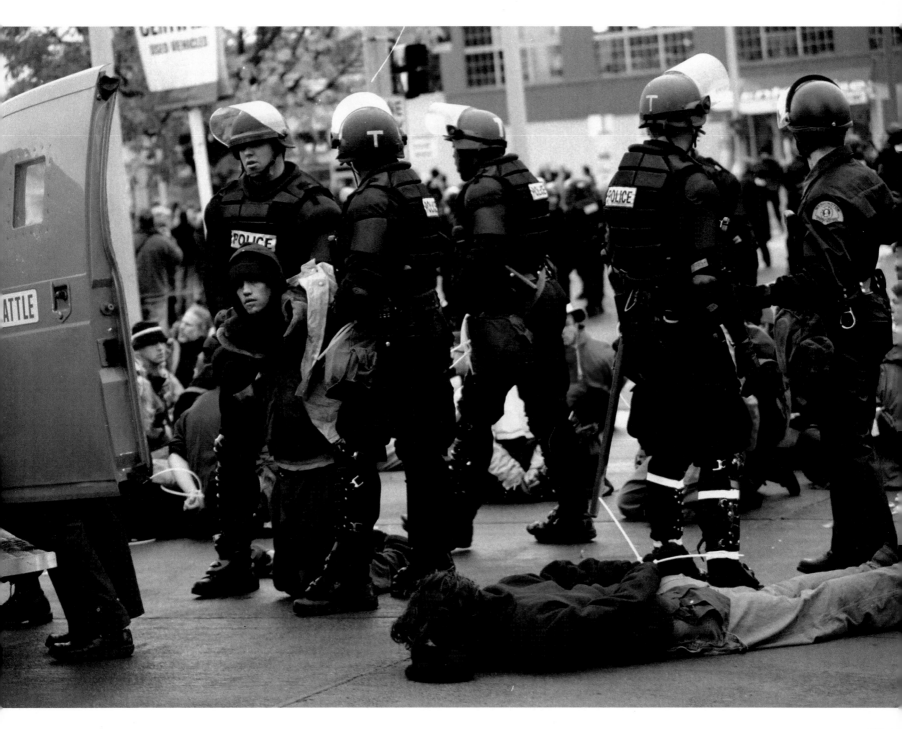

Faces in the crowd

Republican GEORGE NETHERCUTT of Spokane and his sister, Nancy Gustafson, celebrate Nethercutt's victory in November, 1994 over Democrat Tom Foley in the election to the U.S. House of Representatives from Washington's 5th Congressional District. After leaving Congress a decade later, Nethercutt established the George Nethercutt Foundation, a non-partisan organization seeking to improve the civics and leadership education of college students.

U.S. House Speaker TOM FOLEY leaves a press conference in Spokane on November 9, 1994 in which he conceded defeated to Republican George Nethercutt in his campaign for re-election to Congress from Washington's 5th District. Foley became the first sitting speaker to be defeated in a re-election campaign. He had lost support of Congressional Democrats because of the way he handled a Congressional banking scandal and alienated voters back home when he challenged a state initiative to impose term limits. Foley served in the House from 1965-1995, and was speaker from 1989 to 1995, the first speaker from a state west of the Rocky Mountains. After leaving Congress, he served as ambassador to Japan from 1997-2001 under President Clinton.

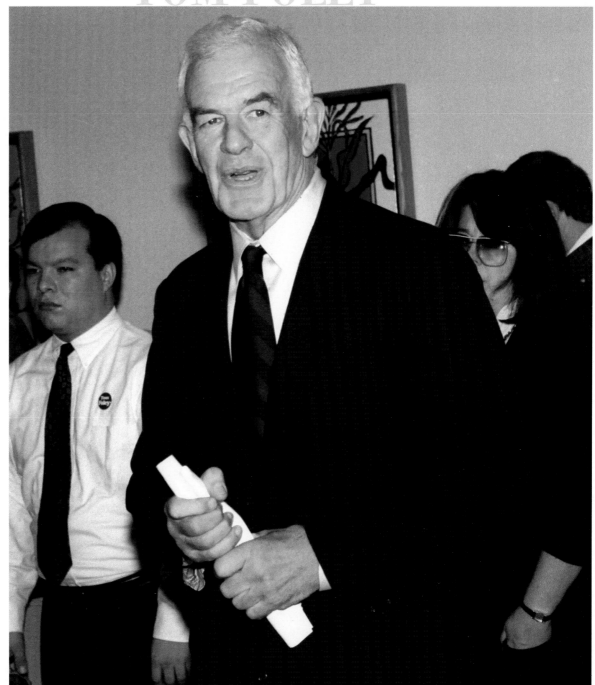

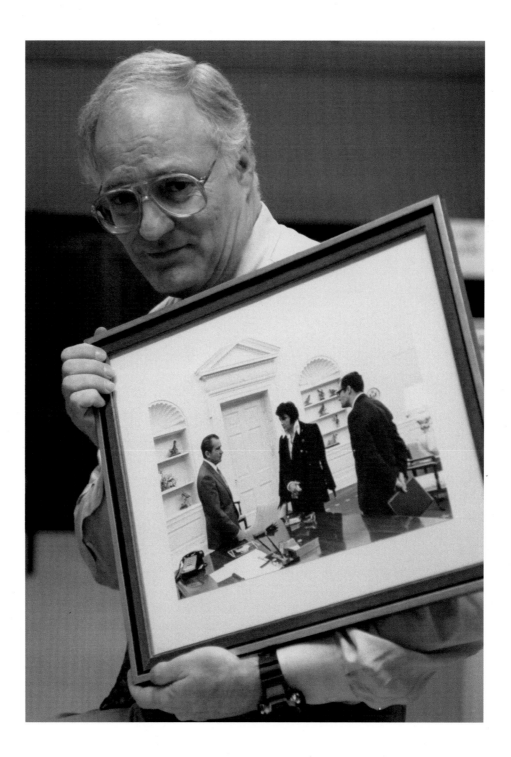

Seattle Times staffers, from left, ERIC NALDER, BYRON ACHOHIDO, DEBORAH NELSON, and ROB WEISMAN celebrate the announcement on April 7, 1997 that the newspaper had won two Pulitzer Prizes. NALDER, NELSON, and ALEX TIZON won for investigative reporting; ACHOHIDO won for best reporting.

EGIL "BUD" KROGH JR., a Nixon White House aide, hangs a photo of President Richard Nixon, himself, and Elvis Presley in his Seattle office in December, 1995. Krogh, who was raised in Seattle, headed the White House Special Investigation Unit, known as the "Plumbers," whose mission was to stem unauthorized "leaks" of information from the White House during the Watergate era. Krogh pleaded guilty to federal charges of conspiring to violate the civil rights of a psychiatrist seeing Daniel Ellsberg, who released the Pentagon Papers critical of the Vietnam war. Krogh served four and one-half months of a two- to six-year prison sentence and then returned to Seattle.

PHIL CONDIT, chief executive officer of The Boeing Co., announces his company's intention to merge with McDonnell Douglas at a news conference in Seattle in December, 1996. The deal between the two aerospace companies was consummated the following year with a $13 billion stock swap, propelling the new company ahead of Lockheed Martin as the nation's largest defense contractor.

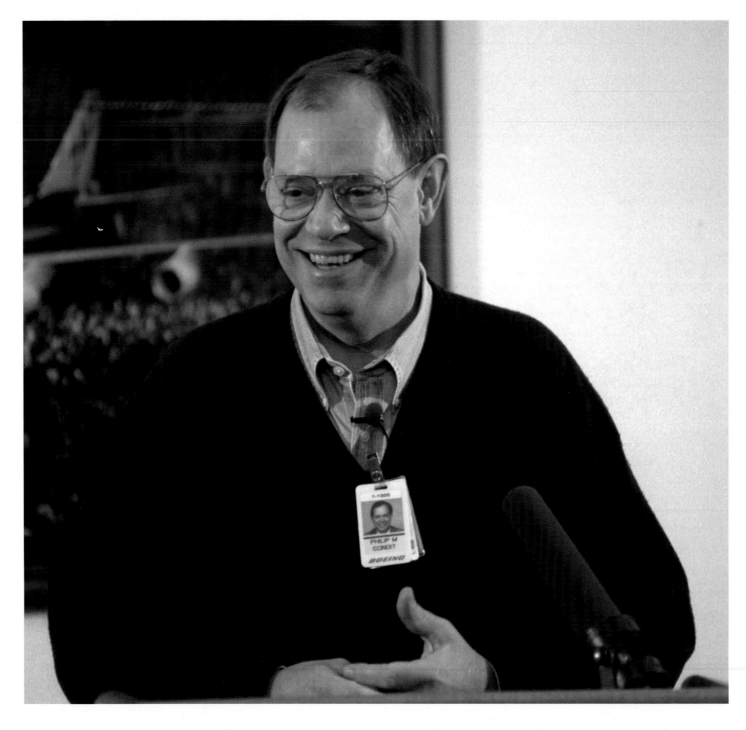

Washington Governor MIKE LOWRY enjoys a cup of coffee in Seattle in October, 1996. Lowry served as U.S. Representative from Washington's 7th District from 1979 to 1989 and then as governor from 1993 to 1997. He decided not to seek re-election as governor after a sexual harassment scandal in which a deputy press secretary accused him of making inappropriate remarks and fondling her.

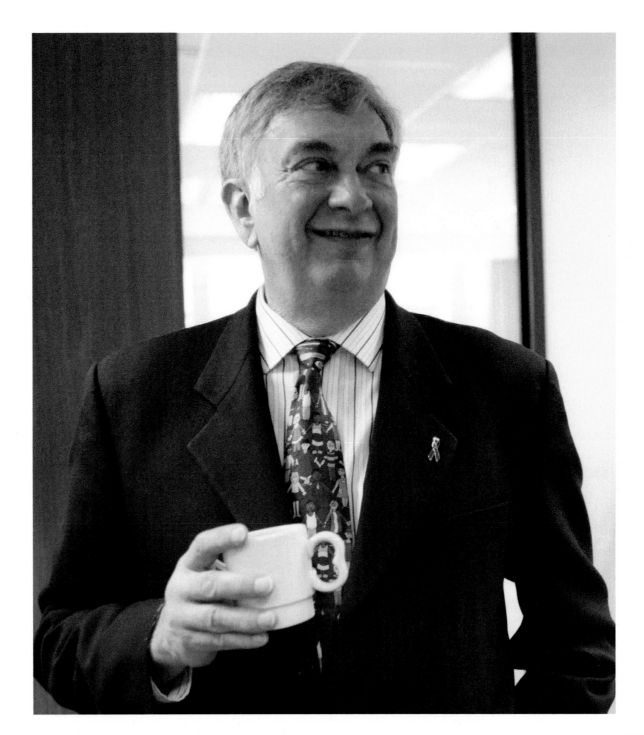

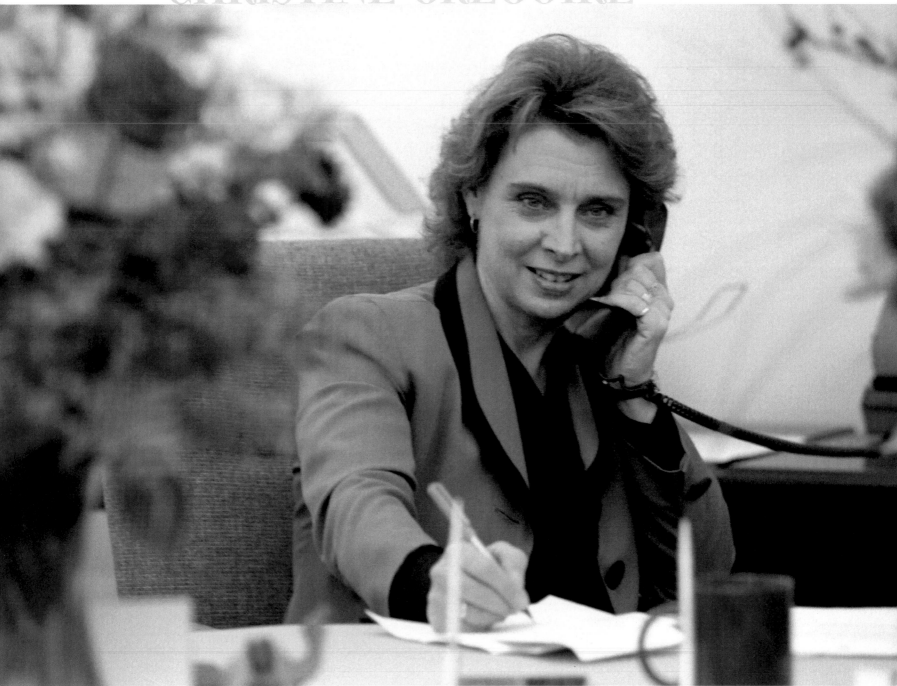

Washington Attorney General CHRISTINE GREGOIRE was one of the leaders in a class-action lawsuit by forty-six states against the four largest U.S. tobacco companies seeking to recover tobacco-related health-care costs and curtail certain marketing practices. In the November, 1998 settlement the companies agreed to pay more than $200 billion over twenty-five years. Gregoire was elected governor in 2004 after several contentious recounts and then re-elected in 2008, defeating Republican challenger Dino Rossi in both elections.

GARY LOCKE and his wife, MONA LEE, a former television reporter, cast their ballots in a 1996 election. A native of Seattle, Locke served as governor of Washington from 1997 to 2005, after which he was appointed secretary of commerce under President Obama and then named ambassador to the People's Republic of China in 2011.

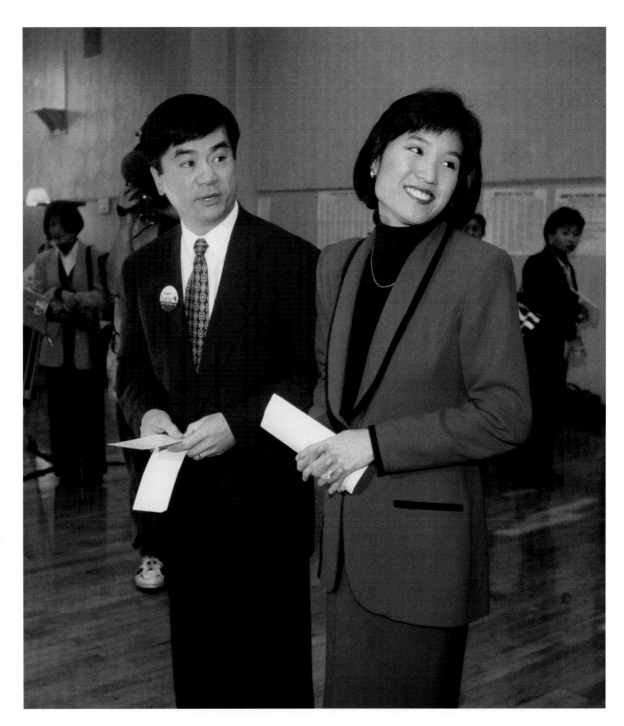

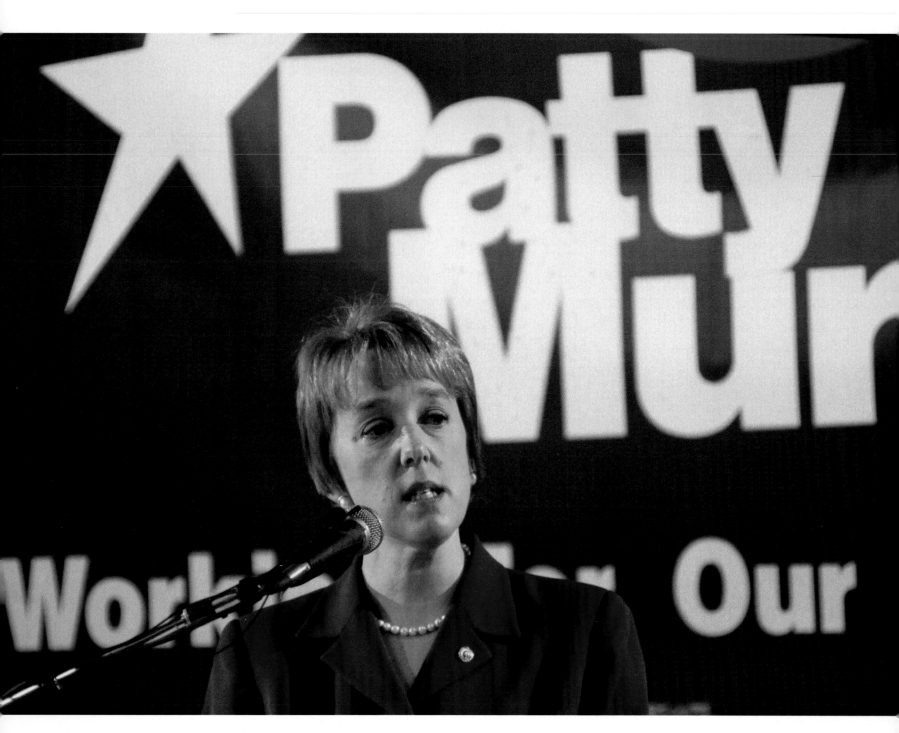

PATTY MURRAY announces her bid for a second term to the U. S. Senate at a rally in the Everett area in April, 1998. Murray, a Democrat, went to the Senate in 1992 after a successful campaign in which she depicted herself as "a mom in tennis shoes." Murray won the 1998 election and was re-elected in 2004 and 2010.

GEORGE W. BUSH visits the Seattle Boys and Girls Club in Seattle on July 8, 1999, one of many stops in his campaign for the presidency. Bush was the Republican nominee in 2000. In November, he lost the popular vote nationally by about 500,000 votes but beat Vice President Al Gore in the Electoral College.

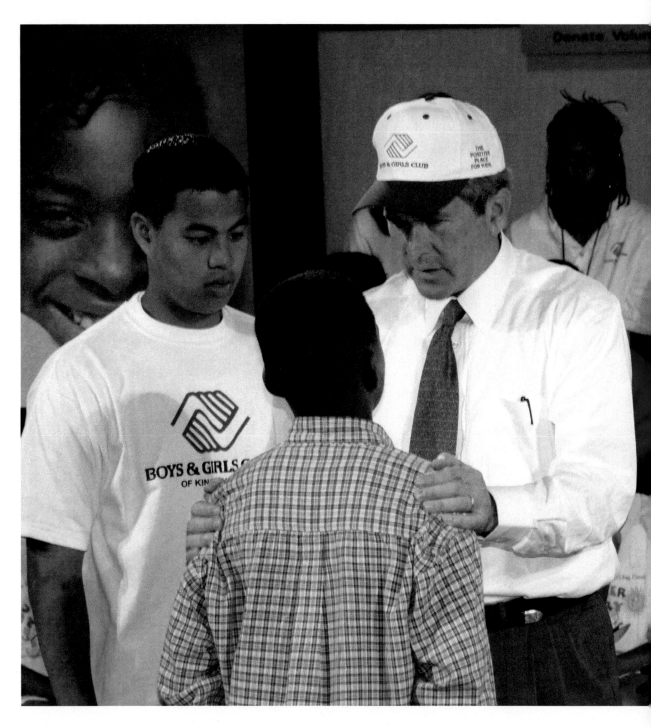

The dot.com bust in the early 2000s hit Seattle with an uppercut punch. The bubble created by the growth of internet companies in the previous decade began losing air in the early years of the new millennium as the U.S. economy began to lose speed and the stock market plunged. Dot.com companies short on capital and profits began folding. Laid-off computer programmers and other internet technology experts formed unemployment lines reminiscent of the dark days at Boeing in the 1970s.

Boeing was still in the news in the new decade. The Boeing Dash 80, prototype of the world's first commercially successful jetliner, the 707, made its final flight and headed for the Smithsonian National Air and Space Museum in Washington, D.C. Meanwhile, Boeing employees celebrated the launch of the company's new 7E7 Dreamliner, renamed the 787 in 2005. However, as the first decade of the 2000s came to a close, production of the new plane was plagued by delays.

In sports, it was a mixed bag. The historic Kingdome, which had served for twenty-five years as a home for the Mariners, the Seahawks, the Sounders, and on occasion, the SuperSonics, fell to the modern-day version of the wrecking ball—demolition explosives.

The SuperSonics? They were sold and moved away, leaving an aftermath of bitterness and anger in Seattle, after being sold by Starbucks coffee baron Howard Schultz to a group of Oklahoma businessmen in 2006. However, Seattle sports fans were cheered by the return of "Junior"—Ken Griffey Jr.—after a ten-year absence in Cincinnati and Chicago. His retirement in 2010 and that of Edgar Martinez in 2004 left fans with happy memories, but no World Series championship, from the Mariners' glory years in the 1990s.

2000s: dawn of a new century

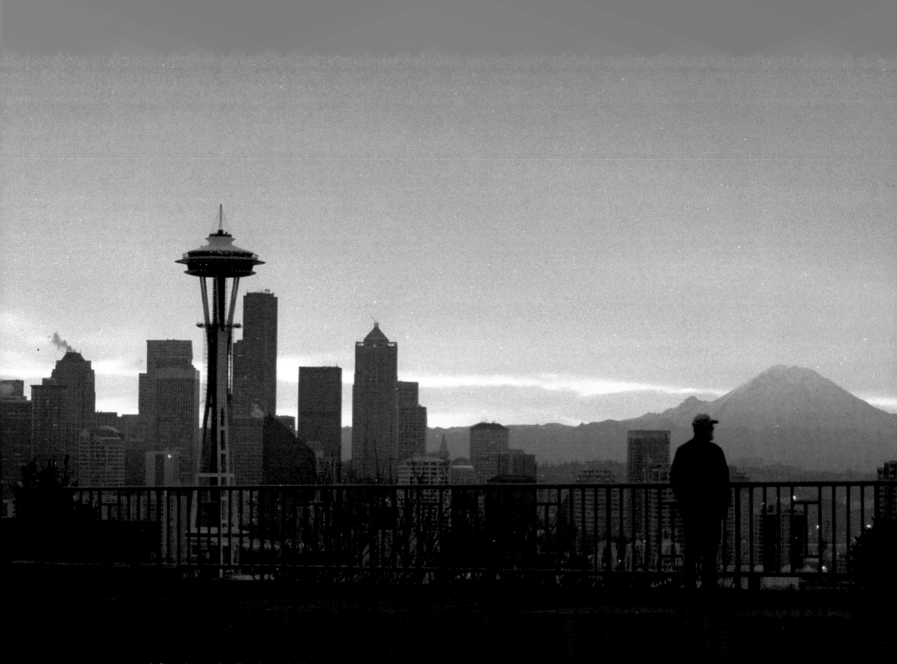

A Seattle sunrise illuminated this view of the city's skyline with the Space Needle and Mount Rainier in the background.

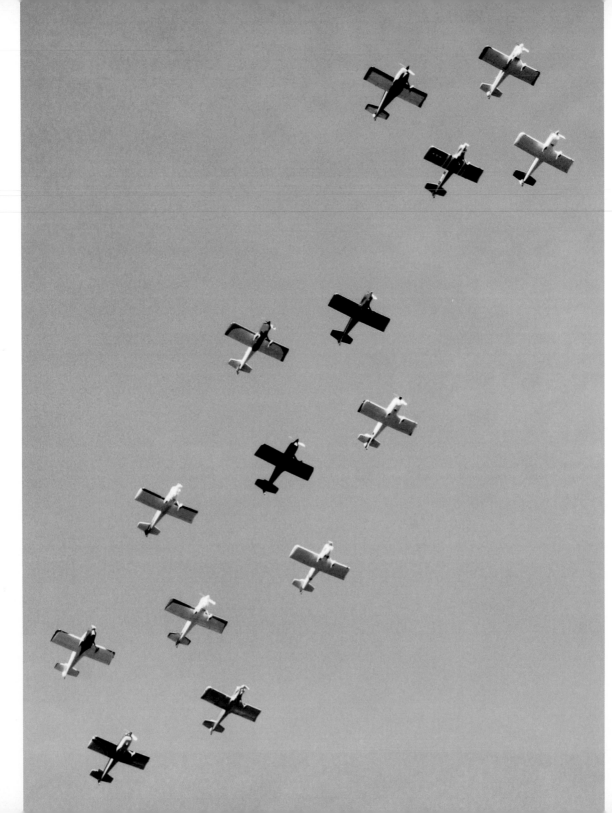

Fourteen small planes fly in close order over Seattle on December 13, 2003 celebrating the 100-year anniversary of the Wright Brother's first powered flight.

KEVIN CORTEZ was one of the first boarders to use the Seattle Center's new 8,800-square-foot Skate Park that opened in June, 2000, featuring a nine-foot-deep bowl.

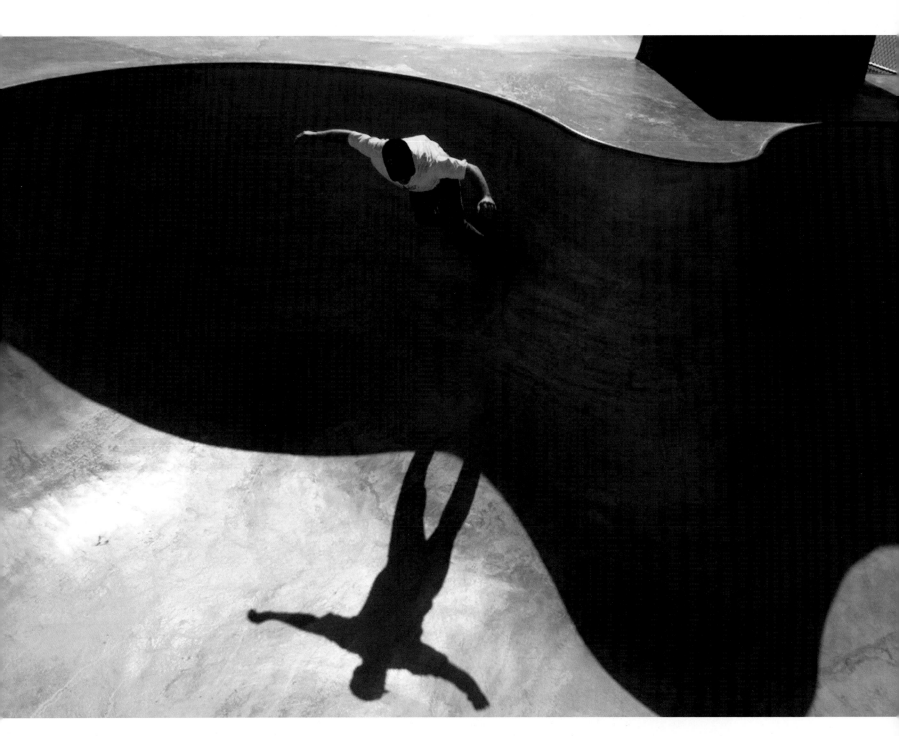

The Seattle Space
Needle is partially
obscured in a fog
bank hanging
over the city in
October, 2000. The
tower was built by
private investors
for the Century 21
Exposition in 1962,
when nearly 20,000
people a day
rode high-speed
elevators to the
observation deck.
The steel tower
weighs 3,700 tons
and is anchored
to the ground
by seventy-four
huge bolts, each
thirty-two feet
long. According to
historylink.org, the
needle was built in
nine months at a
cost of $4.5 million.

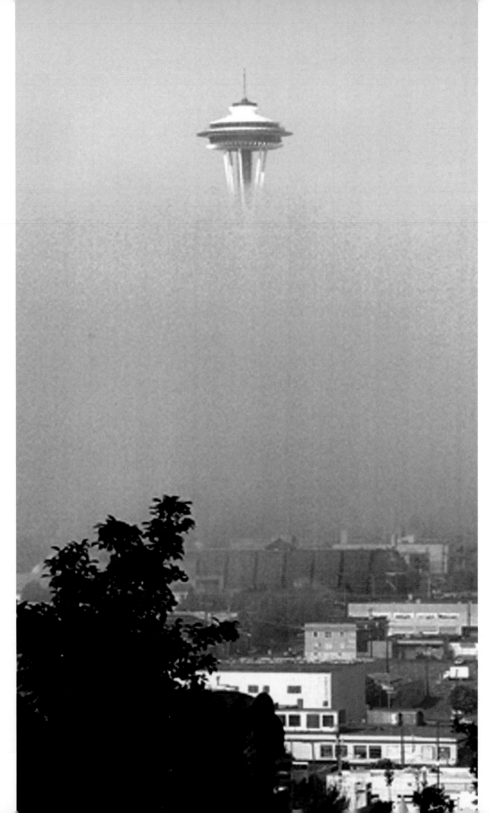

A giant hot-air balloon modeled after
the Statue of Liberty lifts from a hillside
at Seattle's Gas Works Park as the city
prepares for a Fourth of July celebration
and fireworks display in July, 2003.

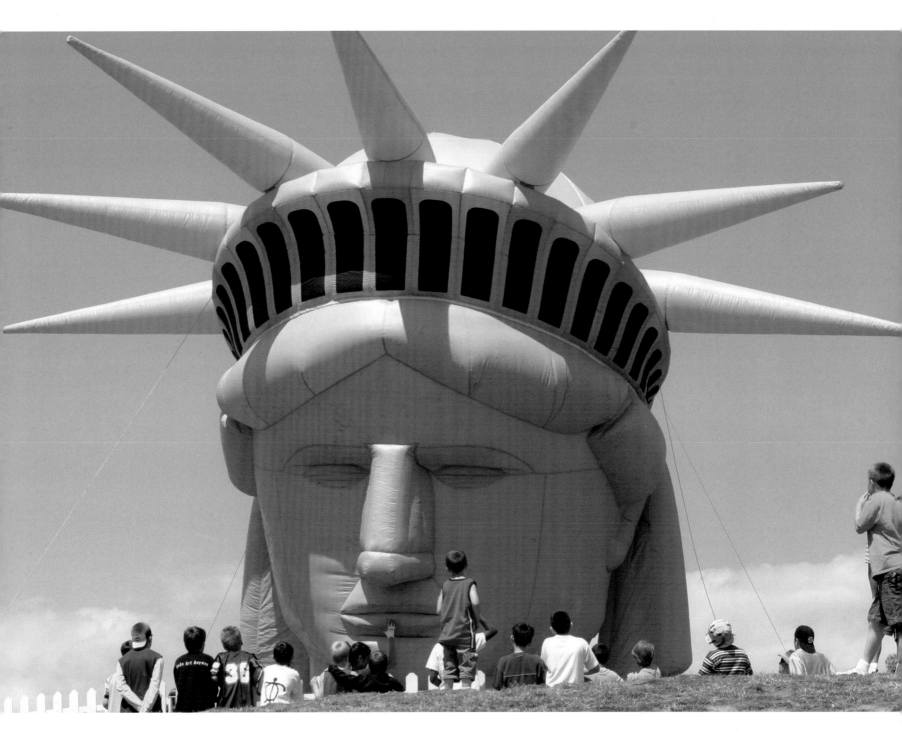

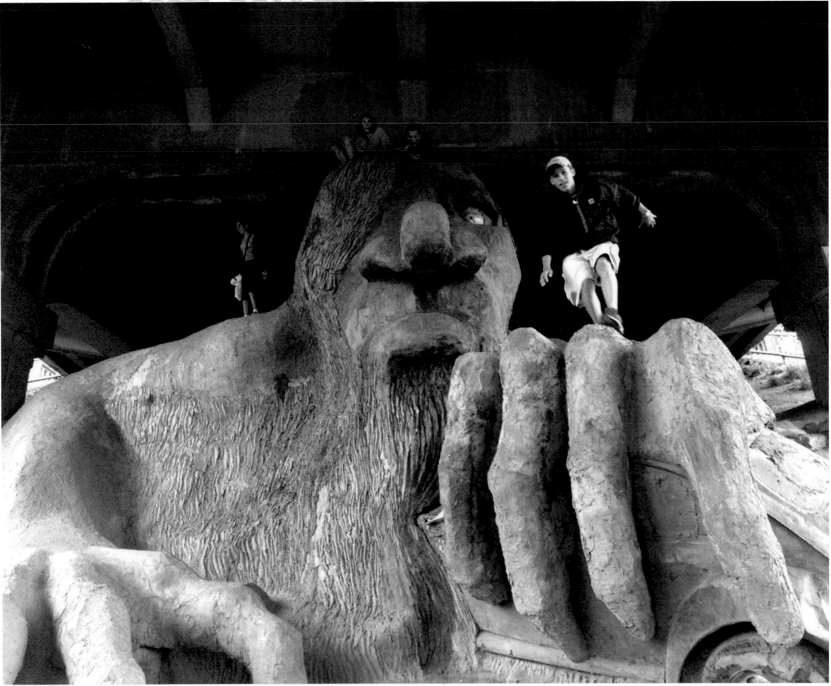

Aaron Rose jumps off THE TROLL under the Aurora Avenue Bridge in Seattle's Fremont District in June, 2000. The Troll is a creation of four Seattle-area artists.

This unusual piece of artwork got a lot of double-takes from visitors strolling through the gardens at the Bellagio Resort in Las Vegas in June, 2008.

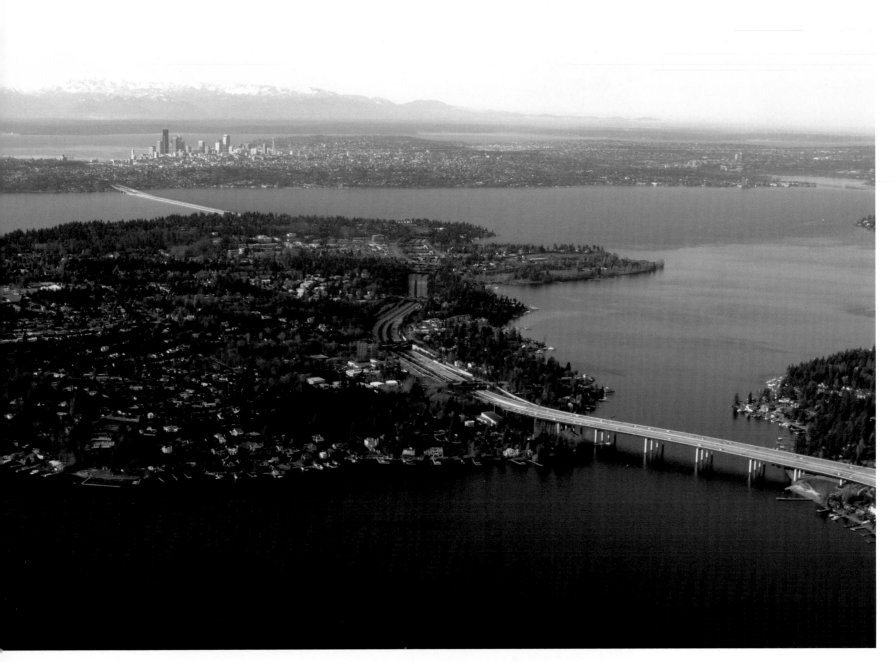

An aerial view of Mercer Island in December, 2003 shows
Interstate 90 and its floating bridges connecting Seattle to
suburban Bellevue across Lake Washington.

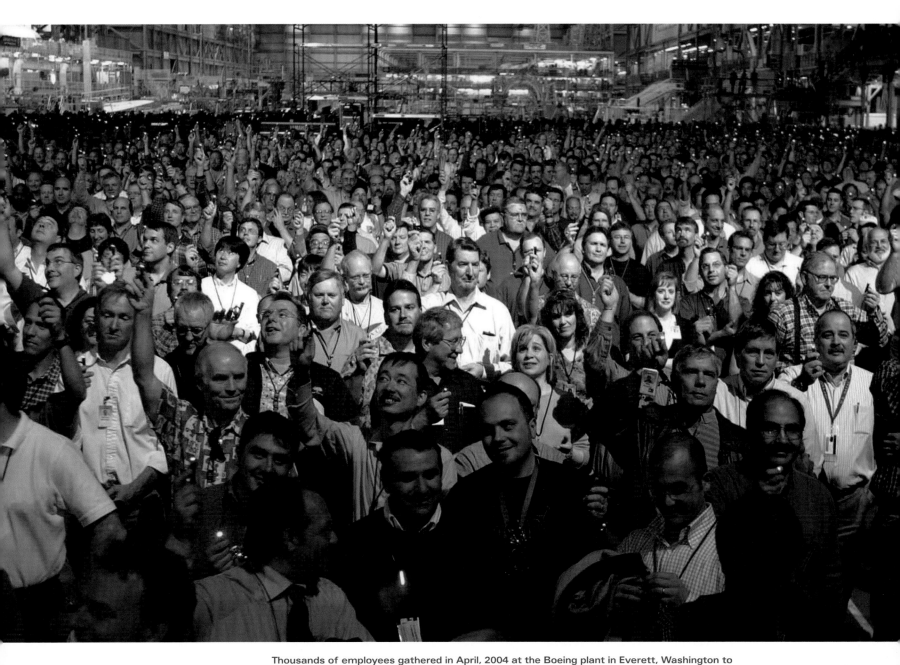

Thousands of employees gathered in April, 2004 at the Boeing plant in Everett, Washington to celebrate the aerospace company's announcement that it would launch the 7E7 Dreamliner, an energy-efficient jetliner incorporating various innovations to make passengers more comfortable.

Building airplanes for the world

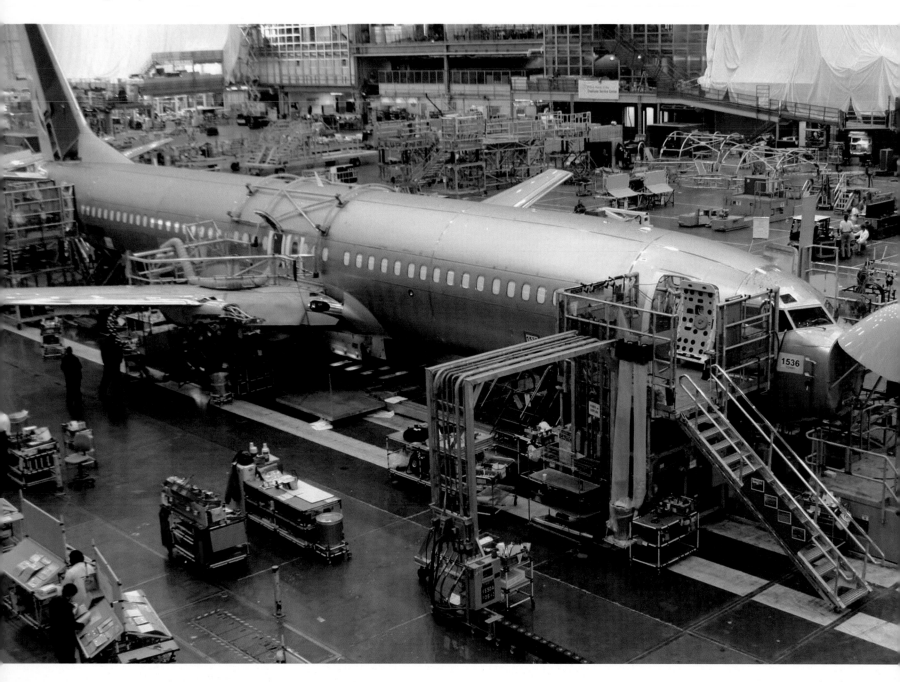

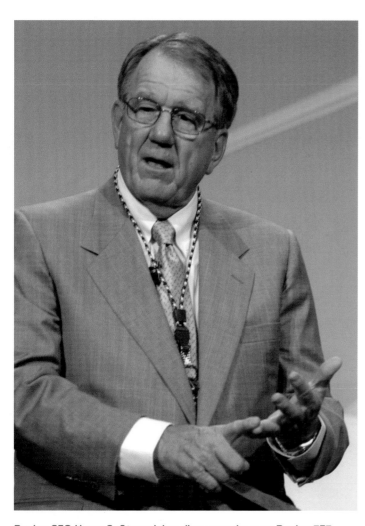

Boeing CEO Harry C. Stonecipher discusses the new Boeing 7E7, later renamed the 787 Dreamliner, at a news conference in Seattle on December 16, 2003. The new jet seats 210-290 passengers. It is the first major jetliner to be made largely of composite materials.

A Boeing 737 gets a nose section on the assembly line at the Boeing plant in Renton, Washington in June, 2004.

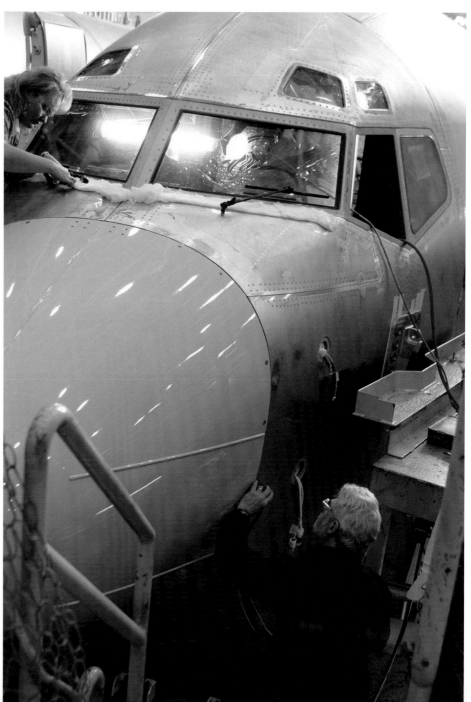

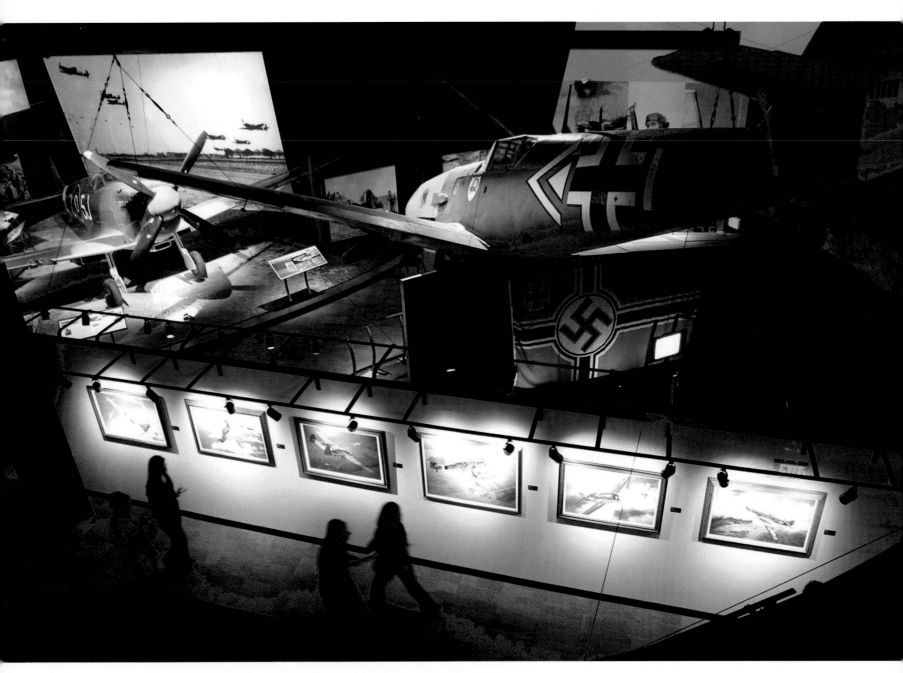

Airplanes line the walls and floor area at Seattle's Museum of Flight in June 2004 in preparation for the grand opening of the Personal Courage Wing displaying twenty-eight aircraft from World War I and World War II.

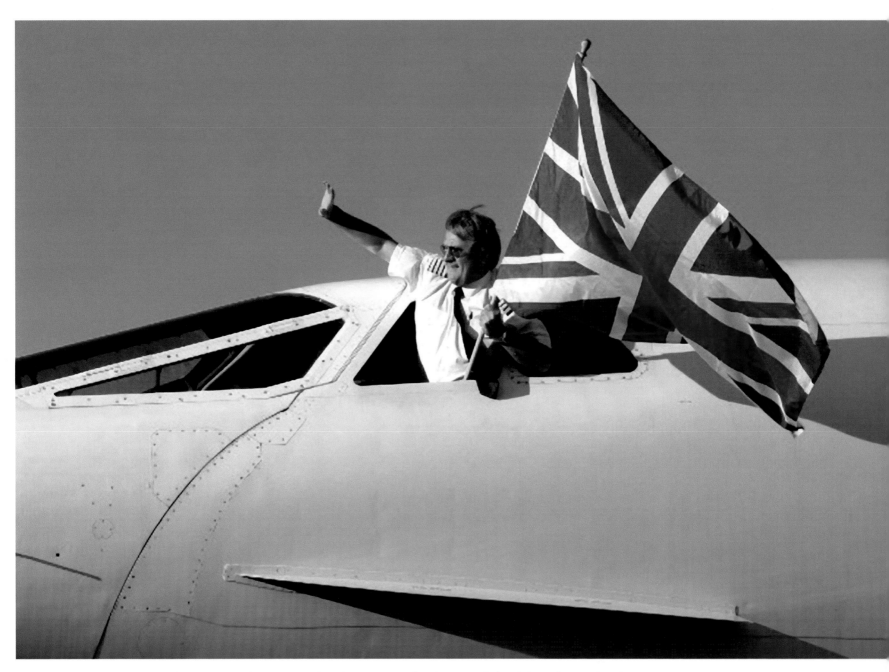

British Concorde pilot Captain Mike Bannister waves a flag from a cockpit window after landing his supersonic transport in Seattle in November, 2003. The aircraft was retired from service and became a permanent exhibit at the Museum of Flight.

Skagit valley

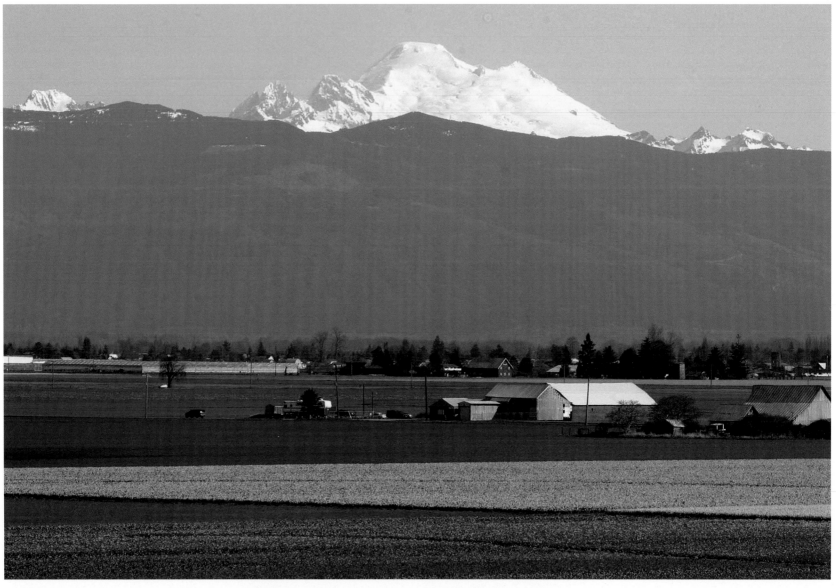

With Mount Baker in the distance, blooming flowers in Skagit
Valley fields near Mount Vernon burst into a sea of color in March,
2004, bringing thousands of spring tourists to the area.

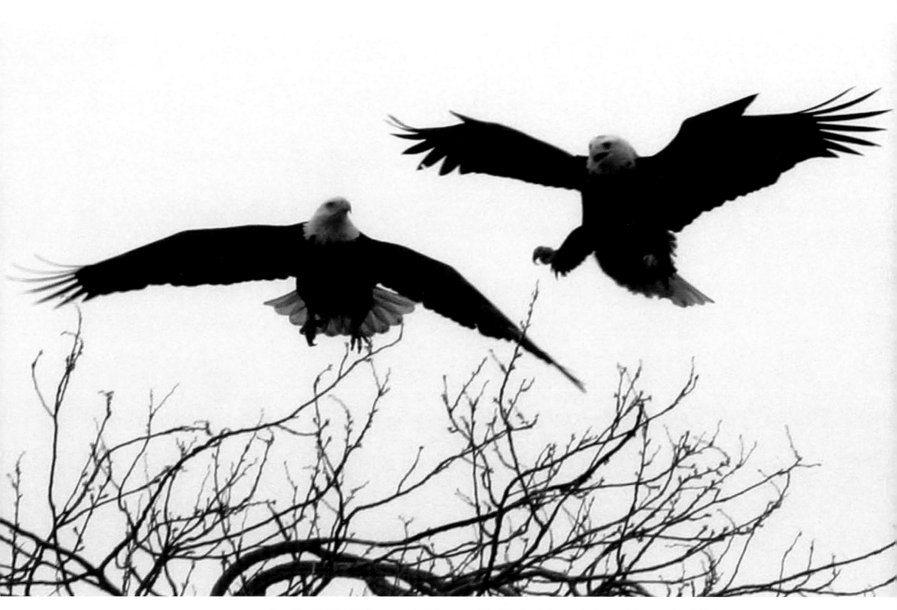

The Skagit Wildlife Area west of Conway, Washington is home to tens of thousands of birds

during the winter months, including these two eagles landing on a tree in January, 2004.

Visitors see snow geese, trumpeter swans, and eagles as well as other birds and wildlife.

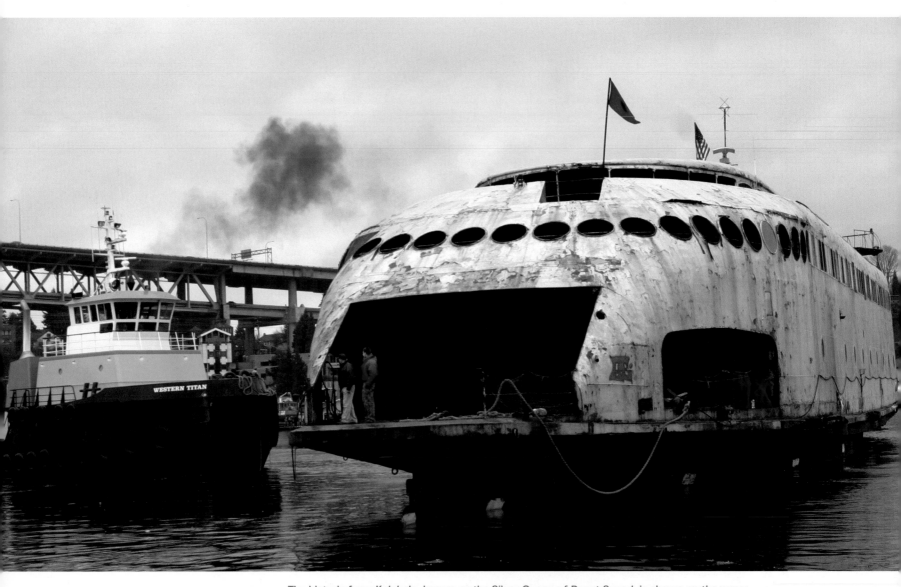

The historic ferry Kalakala, known as the Silver Queen of Puget Sound, is shown on the move in Seattle's Lake Union in March, 2004. The 276-foot vessel, launched in 1935, was headed for Neah Bay in northwest Washington. She was later towed to Tacoma, where the owner sought unsuccessfully to raise funds for restoration of the vessel. The Kalakala carried passengers until 1967 before going to Alaska, where it served as a fish-processing plant for many years.

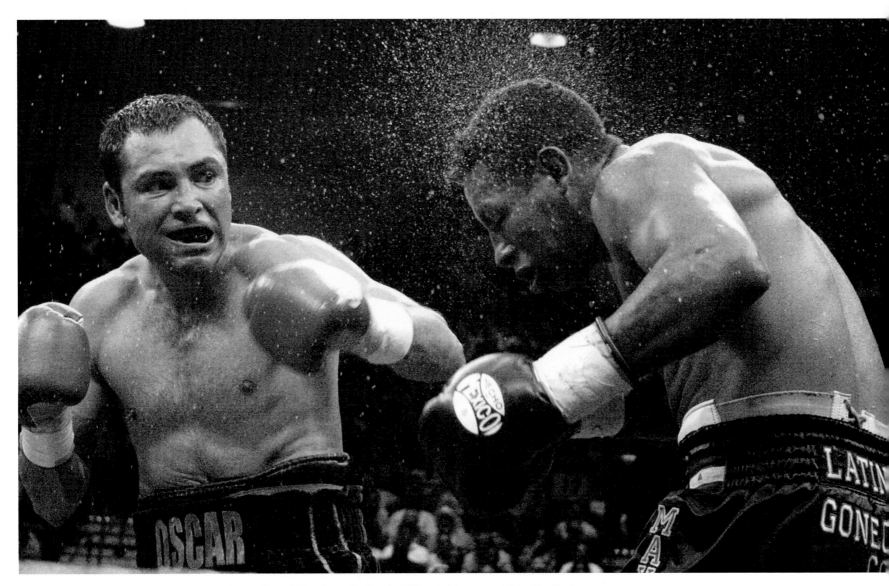

Sweat flies from the head of Ricardo Mayorga, right, after the boxer was belted by a nasty left from Oscar de la Hoya in the sixth round of their World Boxing Council's Super Welterweight Championship fight in Las Vegas, Nevada in May, 2006. De la Hoya scored a sixth-round TKO to win the title, his 10th world title in six weight classes.

Two sides to the Iraq war

A couple kisses goodbye after deployment ceremonies for the Washington State Army National Guard's 81st Armored Brigade in Tacoma in February, 2004. Some 4,000 soldiers were preparing to leave for Iraq in the largest deployment of state guard personnel since World War II.

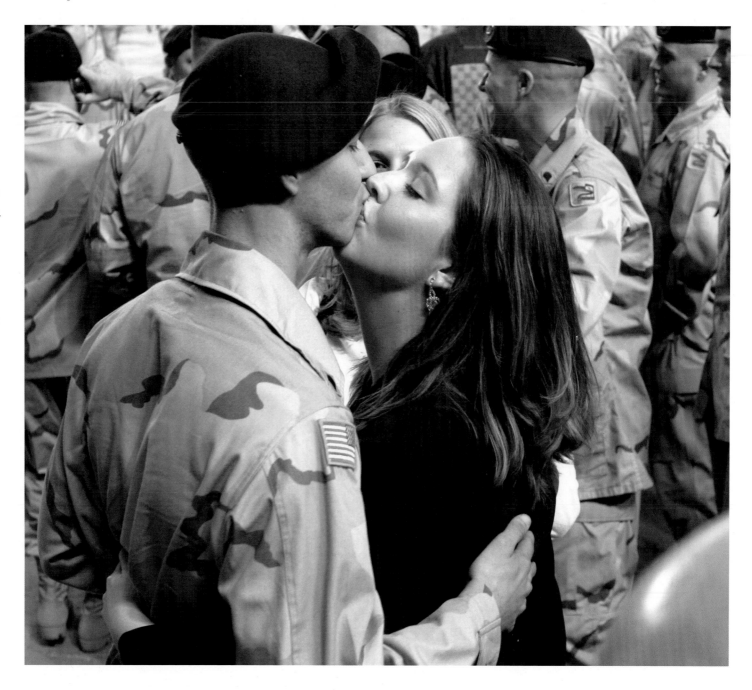

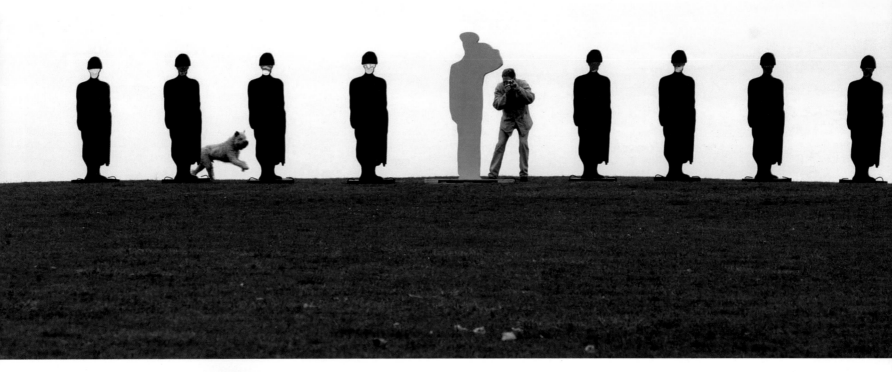

In what Seattle park officials saw as "guerilla art" protesting the Iraq war, this display of nine life-size plywood figures depicting soldiers mysteriously appeared on Kite Hill at the Sand Point Magnuson Park in January, 2004. Eight of the figures had mirrors in place of faces. The central figure looked like an officer. Park officials said they didn't particularly want to "encourage random pieces of art," but left the display up for a few months before removing it.

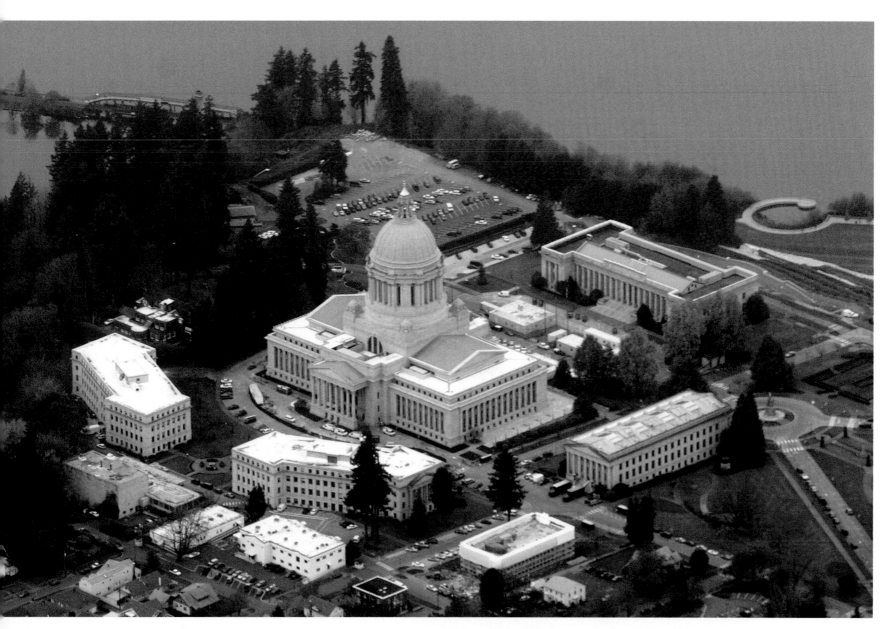

The Washington State Capitol Building stands out among a complex of state office buildings in Olympia in November, 2004. The layout of lesser office buildings surrounding the dominant Capitol with its 278-foot-high dome was considered to be innovative when completed in 1924. The building underwent a facelift in 1986 and an extensive second renovation in the first decade of the 21st Century.

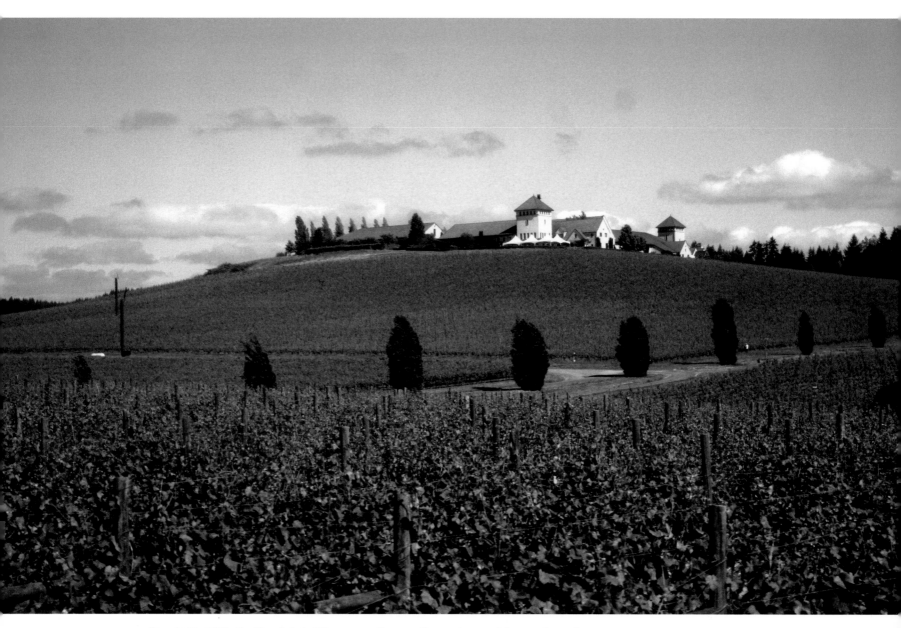

Founded in 1991, the King Estate Winery near Eugene, Oregon is one of the most popular producers of pinot gris and pinot noir wines in the United States. In 2012, Oregon's wine grape industry grew 41,500 tons of grapes, a record.

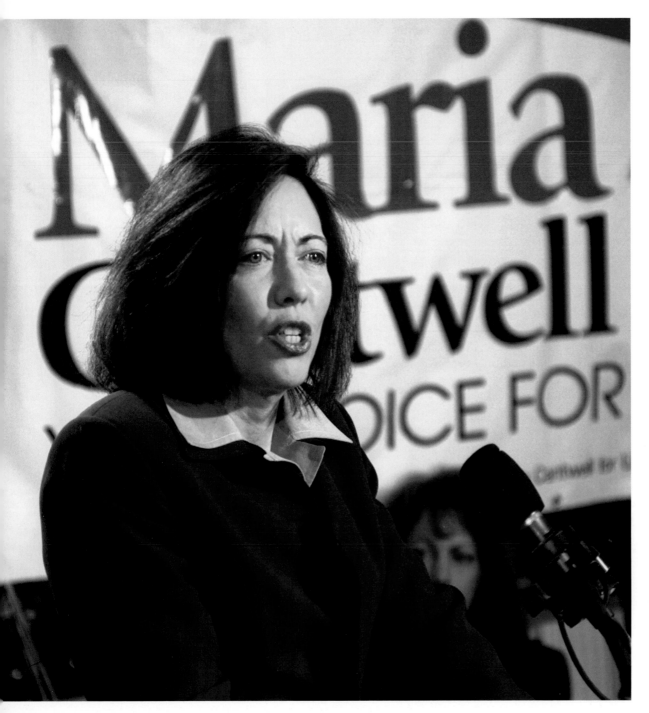

Faces in the crowd

Democrat MARIA CANTWELL announces her candidacy for the U.S. Senate from Washington state in May, 2000. She scored an upset victory over Republican incumbent Slade Gorton that year and won re-election in 2006. Previously Cantwell served a term in the U.S. House of Representatives, 1993-95, from Washington's 1st Congressional District.

On August 7, 2000, University of Washington head football coach RICK NEUHEISEL talks about his team's prospects for the coming season. The Huskies won the Pacific 10 title in 2000 and won the Rose Bowl the following year. An NCAA investigation of a betting pool on college basketball eventually led to Neuheisel's firing after four seasons, 1999-2002. .

Musician-songwriter ANN WILSON arrives at the Experience Music Project in Seattle for a pre-opening party in June, 2000. The music museum was built by Microsoft co-founder Paul Allen. Wilson, best known as the lead singer of the rock band "Heart," grew up in Bellevue, Washington.

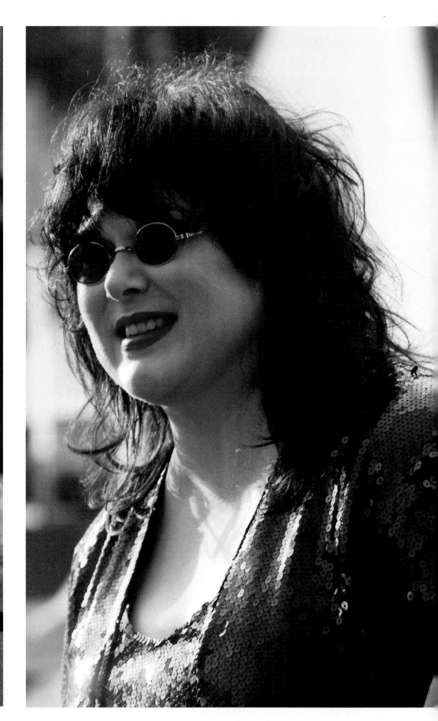

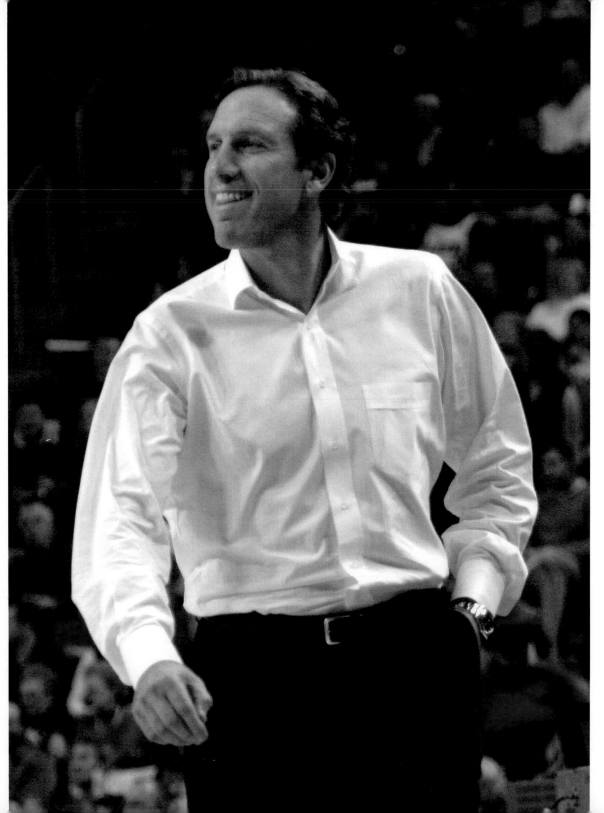

HOWARD SCHULTZ, CEO of Starbucks and then owner of the Seattle Supersonics, enjoys the basketball team's victory over the visiting Portland Trail Blazers in November, 2003. Three years later, after unsuccessful efforts to secure taxpayer funds to upgrade the Key Arena, the Sonics' home court, Schultz sold the team to a group of Oklahoma businessmen. The buyers moved the team to Oklahoma City, much to the chagrin and anger of Seattle fans, many of whom still have not forgiven Schultz for letting Seattle's NBA franchise get away.

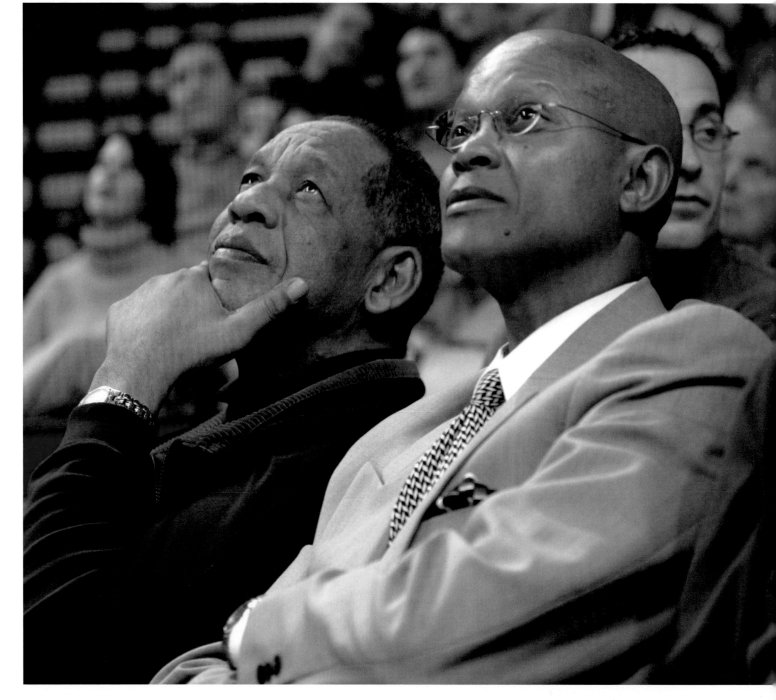

Former Seattle SuperSonics JOHN "J.J." JOHNSON, left, and SLICK WATTS watch the Sonics play the Miami Heat in Seattle on November 18, 2003. Both players starred for the Sonics in the 1970s. Johnson was a member of the 1979 NBA Championship team.

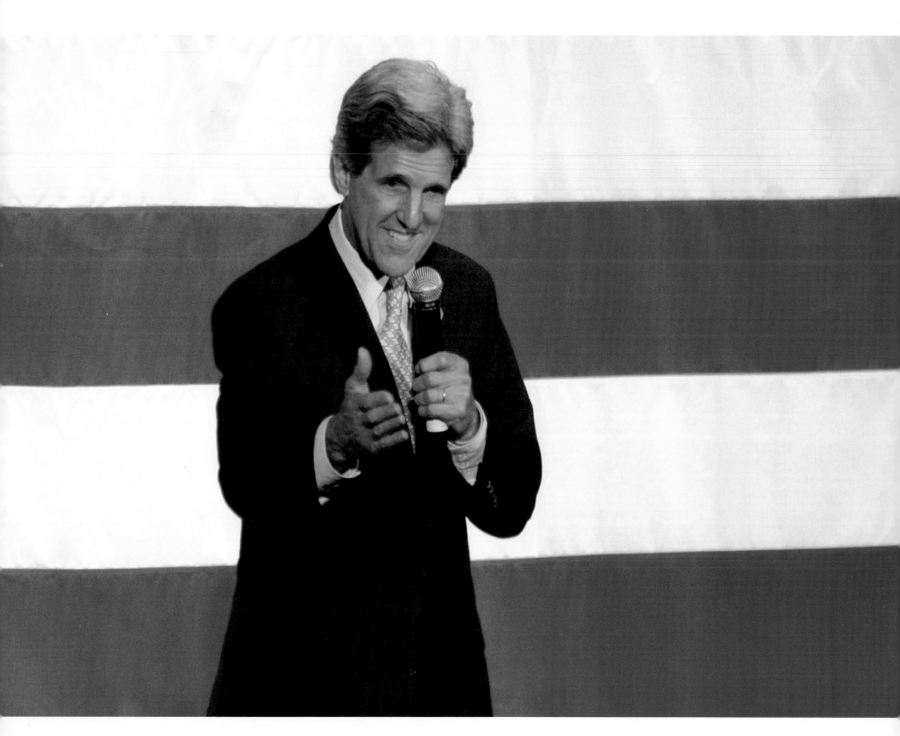

Democratic presidential candidate JOHN KERRY campaigns at a rally in Seattle in August, 2004. The Massachusetts senator defeated President George W. Bush in Washington state's General election but lost the national election.

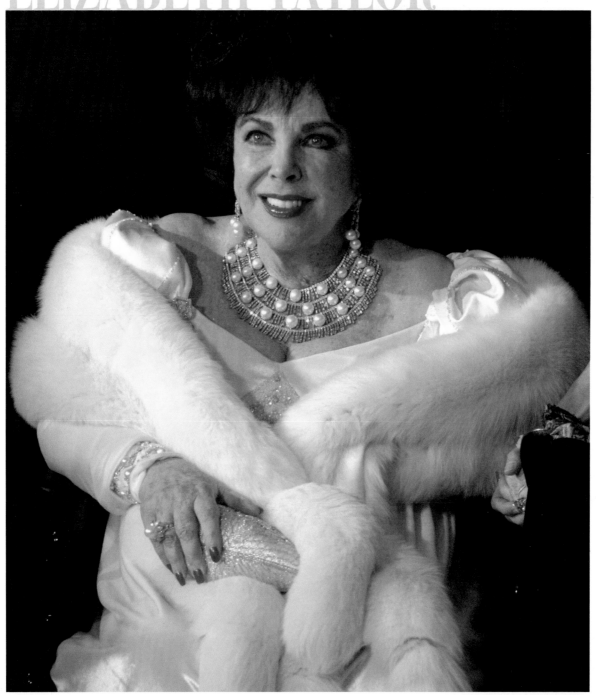

Decked out in lavish jewelry and fur, ELIZABETH TAYLOR was fashionably late for her seventy-fifth birthday party in Las Vegas on February 28, 2007.

Microsoft's STEVE
BALLMER makes a
presentation at the
company's annual
stockholders'
meeting in
November, 2004
in Bellevue,
Washington. He
joined Microsoft
in 1980, heading
several divisions
before his
promotion to
president in 1998
with day-to-day
responsibility
for running the
company. In 2000,
he was named
chief executive
officer, with full
management
responsibility for
Microsoft.

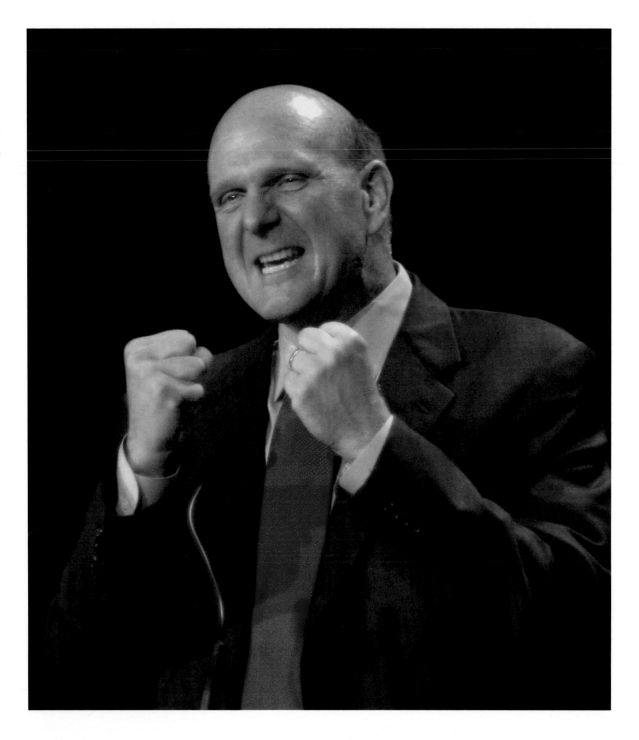

Index

BARRY SWEET

About the Photographer

Barry Sweet, twice nominated for the Pulitzer Prize for his work as an Associated Press photographer, has been taking photographs for fifty years.

Sweet began his photojournalism career in high school with the *Wisconsin State Journal* in his hometown of Madison, Wisconsin. He worked weekends with the *Journal* while attending nearby Whitewater State College and eventually enrolled at the Layton School of Art in Milwaukee, affiliated with Marquette University. There he pursued an intensive two-year course in photography and academics, studying under master photographer Gerhard Bakker.

While in college he entered seven photographs in the National Collegiate Photo Competition at the University of Missouri and won five awards. The award-winning photographs caught the eye of Rich Clarkson, photo director at the *Topeka Capital-Journal*, one of the most photo-minded newspapers in the country. Sweet spent two and one-half years at the newspaper, then joined the AP in 1968.

During a thirty-four-year career with the news agency Sweet's pictures from the Apollo missions, the Alaska pipeline, Wounded Knee, national presidential campaigns, the Olympics, NBA championships, Super Bowls, and the NCAA Final Four graced the pages of newspapers around the world. Since leaving the AP in 2002, Sweet has continued his photojournalism career as a freelance photographer in Las Vegas, Nevada, shooting countless celebrities and stars, championship boxing matches and news and political events. He and his wife, Raleigh, live in Henderson, Nevada.